The Artist's Painting Library

SEASCAPES IN ACRYLIC

BY WENDON BLAKE / PAINTINGS BY RUDY DE REYNA

WATSON-GUPTILL PUBLICATIONS/NEW YORK

Copyright © 1979 by Billboard Ltd.

First published 1979 in the United States and Canada by Watson-Guptill Publications,
a division of Billboard Publications, Inc.,
1515 Broadway, New York, N.Y. 10036

Published in Great Britain by Pitman Publishing Ltd.,
39 Parker Street, London WC2B 5PB
ISBN 0-273-01364-5

Library of Congress Cataloging in Publication Data
Blake, Wendon.
 Seascapes in acrylic.
 (His The artist's painting library)
 Originally published as pt. 3 of the author's
The acrylic painting book.
 1. Sea in art. 2. Polymer painting—Tech-
nique. 3. Marine painting—Technique.
I. De Reyna, Rudy, 1914- II. Title.
III. Series.
ND1370.B573 751.4'26 79-13217
ISBN 0-8230-4728-8

Manufactured in U.S.A.

First Printing, 1979

CONTENTS

Seascapes in Acrylic. When most people hear the word "seascape," they visualize the classic drama of waves breaking against rocks. But this is only one kind of coastal scenery. *Seascapes in Acrylic* shows you how to paint much more than waves and rocks. You'll learn how to paint the rhythmic forms of sand dunes; the looming shapes of cliffs and headlands jutting out into the sea; rock-strewn beaches; and the atmospheric magic of sunlight, fog, and storm. You'll soon see that seascapes are as diversified as the landscapes you'll find inland. And acrylic is an ideal medium for painting these coastal subjects.

Why Acrylic? The best seascapes are painted outdoors—or from color sketches done outdoors. It's exhilarating to crouch in the shadow of a cliff and paint a picture as the salty wind hums around you. It's even more exciting to climb out on the rocks and paint as the water splashes at your feet and the surf flies by. But this sort of painting often means working under pressure, racing to finish before the weather or light changes—or before the tide comes up. Painting in acrylic requires very little equipment. And acrylic paint dries as quickly as watercolor. So it's perfect for painting at high speed, under pressure. If your style is broad and free, you can finish a painting in the first two or three hours of the morning and get back in time for lunch. If you favor precise detail—which takes more painting time—you can block in the major forms of the painting on location in a couple of hours, take the dried painting home under your arm, and complete it from sketches. Or you can make an armload of color sketches in a day and take home enough painting material to keep you busy in the studio for weeks.

Basic Techniques. If you're ready to paint seascapes in acrylic, chances are that you know the basic techniques already. But it's still a good idea to review these basic techniques and see how they apply to coastal subjects. In the pages that follow, you'll see how the opaque and transparent techniques, the wet-in-wet method, scumbling, and drybrush can be used to interpret some typical seascape motifs. First you'll see how to paint surf in the opaque technique. Then you'll learn how to paint waves in a combination of transparent and opaque techniques. You'll watch clouds painted in the wet technique—which means applying color to wet paper—and then more clouds painted with the scrubby brushwork of the scumbling technique. Drybrush is always an effective way to produce texture on rocks. Of course, no one insists that these subjects always be painted in these specific techniques. Surf is often painted in the transparent technique on wet paper. Rocks and impasto go well together. The various combinations are really up to you.

Color Sketches. The colors of the coastline can alter dramatically with changes in light and weather. A series of color sketches will compare waves, surf, skies, and tidepools on sunny and overcast days. You'll also find color close-ups of rocks, dunes, and headlands. Particularly revealing are "lifesize" close-ups of segments of paintings, showing how the paint is applied to interpret the detail of a breaking wave, the dynamic form of surf exploding against the side of a rock, the subtle lights and shadows on a dune, and the intricate planes and textures of a rock formation.

Painting Demonstrations. Following this review of the basic acrylic painting techniques, Rudy de Reyna demonstrates, step-by-step, how to paint ten of the most popular, seascape subjects for which he's famous. You'll watch each specific painting operation as de Reyna paints breaking waves, with their complex pattern of ripples and foam, and the conflict of surf and rocks, an interesting combination of brush and knife painting. Next, de Reyna goes on to paint storm clouds over a massive headland; the haunting light of the moon on a deserted beach; the mystery of fog, half concealing a rocky coastline. Then the artist focuses on the forms of the coastal landscape: a rocky beach with strong contrasts of light and shadow; the delicate colors and rhythmic curves of dunes with their special vegetation; a salt marsh, where the sea invades the land; a rocky headland; and finally the tidepools left on the beach by the receding water.

Special Problems. Following the demonstrations, you'll find a number of guidelines for selecting seascape subjects, plus some useful dos and don'ts for composing successful seascapes. You'll see how the direction of the light can alter the look of your picture. You'll learn how to recognize and paint the effects of aerial perspective. You'll observe how to use the brush more expressively—by studying close-ups of the brushwork in various acrylic seascapes. And finally, to develop your powers of observation, there are studies of different wave, rock, and cloud forms that you're likely to encounter when you paint the coast.

Color Selection. The paintings in this book were all done with a dozen basic colors—colors you'd normally keep on the palette—plus a couple of others kept on hand for special purposes. Although the leading manufacturers of acrylic colors will offer you as many as thirty inviting hues, few professionals use more than a dozen, and many artists get by with fewer. The colors listed below are really enough for a lifetime of painting. You'll notice that most colors are in pairs: two blues, two reds, two yellows, two browns, two greens. One member of each pair is bright, the other subdued, giving you the greatest possible range of color mixtures.

Blues. Ultramarine blue is a dark, subdued hue, with a hint of violet. Phthalocyanine blue is far more brilliant and has tremendous tinting strength—which means that a little goes a long way when you mix it with another color. So add it very gradually.

Reds. Cadmium red light is a fiery red with a hint of orange. All cadmium colors have tremendous tinting strength; add them to mixtures just a bit at a time. Naphthol crimson is a darker red and has a slightly violet cast.

Yellows. Cadmium yellow light is a dazzling, sunny yellow with tremendous tinting strength, like all the cadmiums. Yellow ochre (or yellow oxide) is a soft, tannish tone.

Greens. Phthalocyanine green is a brilliant hue with great tinting strength, like the blue in the same family. Chromium oxide green is more muted.

Browns. Burnt umber is a dark, somber brown. Burnt sienna is a coppery brown with a suggestion of orange.

Black and White. Some manufacturers offer ivory black, and others make mars black. The paintings in this book happen to be done with mars black, which has slightly more tinting strength. But that's the only significant difference between the two blacks. Buy whichever one is available in your local art supply store. Titanium white is the standard white that every manufacturer makes.

Optional Colors. One other brown, popular among portrait painters, is the soft, yellowish raw umber, which you can add to your palette when you need it. Hooker's green—brighter than chromium oxide green, but not as brilliant as phthalocyanine—may be a useful addition to your palette for painting landscapes full of trees and growing things. If you feel the need for a bright orange on your palette, make it cadmium orange—although you can just as easily create this hue by mixing cadmium red and cadmium yellow.

Gloss and Matte Mediums. Although you can simply thin acrylic tube color with water, most manufacturers produce liquid painting mediums for this purpose. Gloss medium will thin your paint to a delightful creamy consistency; if you add enough medium, the paint turns transparent and allows the underlying colors to shine through. As its name suggests, gloss medium dries to a shiny finish like an oil painting. Matte medium has exactly the same consistency, will also turn your color transparent if you add enough medium, but dries to a satin finish with no shine. It's a matter of taste. Try both and see which finish you prefer.

Gel Medium. Still another medium comes in a tube and is called gel because it has a consistency like very thick, homemade mayonnaise. The gel looks cloudy as it comes from the tube, but dries clear. Blended with tube color, gel produces a thick, juicy consistency which is lovely for heavily textured brush and knife painting.

Modeling Paste. Even thicker than gel is modeling paste, which comes in a can or jar and has a consistency more like clay because it contains marble dust. You can literally build a painting 1/4" to 1/2" (6 mm to 13 mm) thick if you blend your tube color with modeling paste. But build it gradually in several thin layers, allowing each one to dry before you apply the next, or the paste will crack.

Retarder. One of the advantages of acrylic is its rapid drying time, since it dries to the touch as soon as the water evaporates. If you find that it dries *too* fast, you can extend the drying time by blending retarder with your tube color.

Combining Mediums. You can also mix your tube colors with various combinations of these mediums to arrive at precisely the consistency you prefer. For example, a 50-50 blend of gloss and matte mediums will give you a semi-gloss surface. A combination of gel with one of the liquid mediums will give you a juicy, semi-liquid consistency. A simple mixture of tube color and modeling paste can sometimes be a bit gritty; this very thick paint will flow more smoothly if you add some liquid medium or gel.

Bristle Brushes. For acrylic painting, you can use the same bristle brushes normally used in oil painting. The top brush is called a *filbert*; its long body of bristles, coming to a rounded tip, will make a soft, fluid stroke. The center brush is called a *flat*; its square body of bristles will make a squarish stroke. The bottom brush is called a *bright*; its short, stiff bristles can carry lots of thick paint and will make a stroke with a distinct texture. Bristle brushes are particularly good for applying thick color.

Nylon and Softhair Brushes. For applying more fluid color, many painters prefer softhair brushes. The top two are soft, white nylon; the round pointed brush is good for lines and details, while the flat one will cover broad areas. The third brush from the top is a sable watercolor brush, useful for applying very fluid color. (You can also buy a big round brush like this one in white nylon, which will take more punishment than the delicate sable.) The bottom brush is a stiffer, golden brown nylon, equally useful for applying thick or thin color.

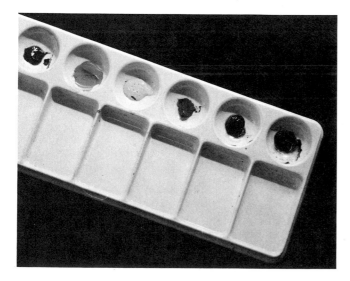

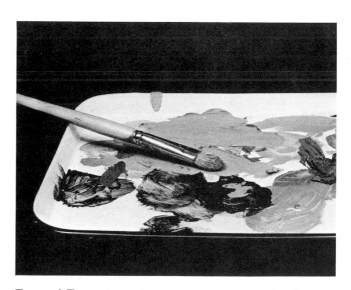

Watercolor Palette. This white plastic palette was originally designed for watercolor painting, but it works just as well for acrylic painting. You squeeze your tube color into the circular "wells" and then do your mixing in the rectangular compartments. These compartments slant down at one end; thus the color will run down and form pools if you add enough water.

Enamel Tray. For mixing large quantities of color, the most convenient palette is a white enamel tray—which you can buy wherever kitchen supplies are sold. You can use this tray by itself or in combination with one or two smaller plastic palettes like those used for watercolor.

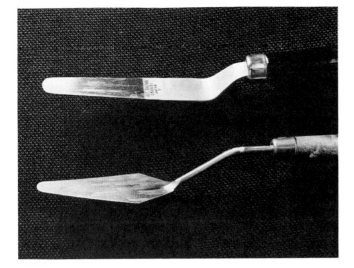

Knives. A palette knife (top) is useful for mixing thick color on your palette—before you add a lot of water—and for scraping wet color off the painting surface if you're dissatisfied with some part of the painting. A painting knife (bottom) has a thin, flexible blade which is designed to pick up thick color from the mixing surface and spread it on the painting surface. The side of the blade will make broad strokes, while the tip can add small touches of color.

Easel. For painting on canvas boards, on canvas, or on panels made of hardboard, most artists like to work on a vertical surface. A traditional wooden easel will hold the painting upright. An easel is essentially a wooden framework with two grippers that hold the painting firmly at top and bottom. Be sure to buy an easel which is solid and stable; don't get a flimsy easel that will tip over when you get carried away with vigorous brushwork.

Wooden Drawing Board. When you paint on watercolor paper—or any sturdy paper—it's best to tape the paper to a sheet of plywood or a sheet of hardboard cut slightly bigger than the painting. If you can, buy plywood or hardboard that's made for outdoor construction work; it's more resistant to moisture. Hold down the edges of the painting with masking tape that is at least 1″ (25 mm) wide or even wider.

Fiberboard. Illustration board is too thick to tape down, so use thumbtacks (drawing pins) or pushpins to secure the painting to a thick sheet of fiberboard. This board is 3/4″ (about 19 mm) thick and soft enough for the pins to penetrate. Note that the pins don't go *through* the painting, but simply overlap the edges.

Step 1. Here's a good coastal subject for trying out the opaque technique: surf exploding against the sky as a wave crashes into a massive rock formation. Solid, creamy color, diluted with just enough water or medium to make the paint flow smoothly, will capture the weight and solidity of the rocks. The foam will obviously contain lots of titanium white, which is one of the most opaque colors on your palette. The pencil drawing (on a sheet of illustration board) clearly defines the shapes of the rocks, but defines the surf with just a few casual lines that will soon be covered with strokes of opaque color.

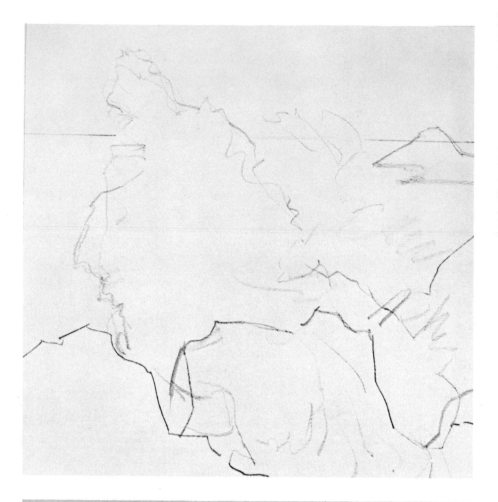

Step 2. The sky and sea are quickly covered with opaque tones containing lots of white. It's important to lighten your tube colors with white, not with water. The foam will be painted with still lighter strokes that easily cover these underlying tones. At this stage, the surf and rocks remain bare illustration board.

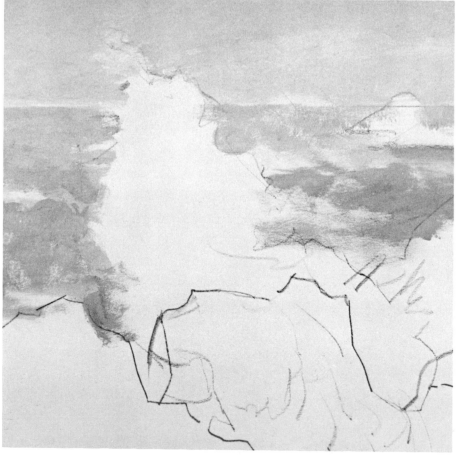

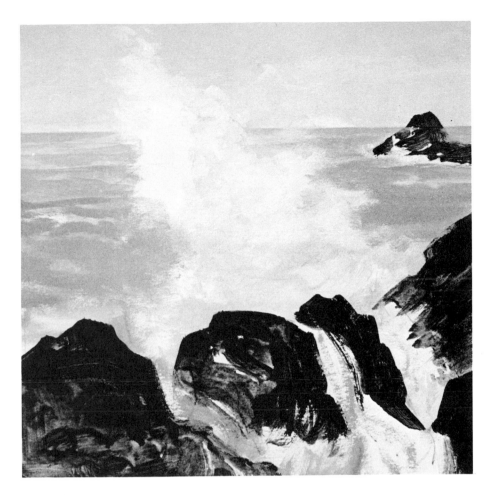

Step 3. A very pale tone, mostly white, is brushed over the foam area, covering the pencil lines and going slightly beyond the lines to cover some of the darker sea and sky. Smaller strokes of this mixture are carried over the sea to suggest the foamy tops of waves moving into shore. And some darker mixtures are brushed between these lighter strokes to suggest the shadowy faces of the distant waves. Darker tones are brushed loosely over the rocks with a brush that leaves the imprint of its bristles, suggesting the rocky texture. This dark tone contains more water than the other mixtures, so it's only semi-opaque, revealing some of the light tone of the illustration board.

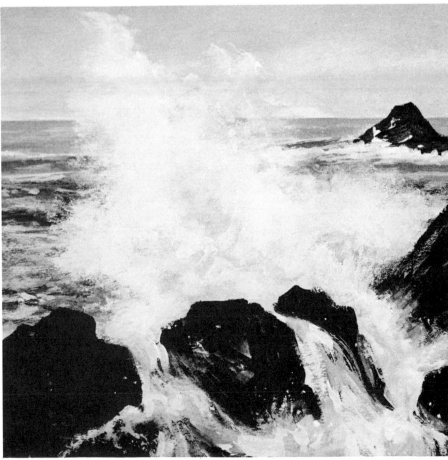

Step 4. The sky, sea, and rocks are darkened with more strokes of opaque color. Now the thick color on the rocks makes them look heavy and solid. The brush comes back to the surf with thicker color than before, extending the shape of the exploding foam farther over the sea and sky—easily covered by the dense white. Strokes of this mixture are carried across the distant waves to suggest more foam, then pulled downward over and between the rocks to suggest foam splashing and spilling into the foreground. The light tones easily cover the dark ones—which is the whole point of the opaque technique.

Step 1. There are many times when a subject calls for a combination of transparent and opaque color. The luminosity of water, for example, is easy to capture with transparent color that's diluted with water, rather than with opaque white. The white painting surface shines right through the transparent color and gives you a sense of inner light. On the other hand, crashing surf tends to look dense and opaque, which is a good reason for painting foam in thick color that's lightened with white, not with water. The pencil drawing traces the top edges of the waves and defines the shapes of the foam.

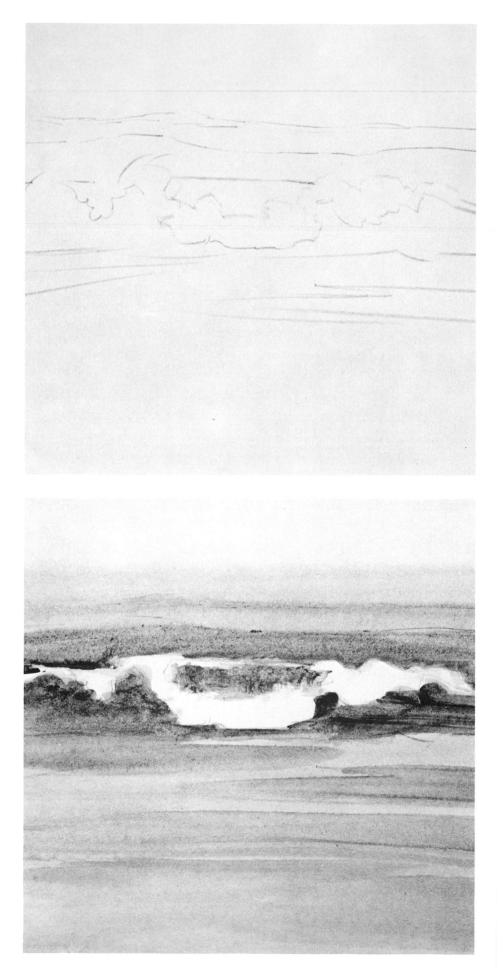

Step 2. The shallow water in the foreground is painted with horizontal strokes of tube color diluted with a great deal of water; thus the color barely conceals the white surface of the illustration board. The tone of the water is darkened—more tube color and less water—and the brush carefully paints the shadowy tones of the face of the wave plus the dark top. The tip of the brush moves around the shape of the foam, leaving the painting surface bare. Then the distant sea and sky are stroked with clear water. While this area is still damp, the brush suggests the distant waves with horizontal strokes of transparent color that blur slightly on the moist surface.

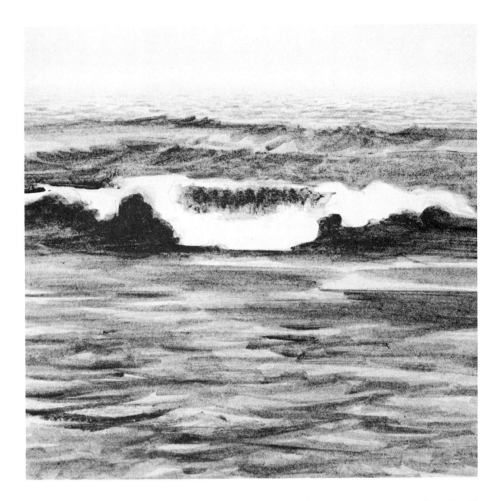

Step 3. Still working with transparent color, the tip of a round soft-hair brush adds slightly curving, horizontal strokes of dark, transparent color to the foreground. These strokes suggest the details and the movement of the shallow waves moving up the beach. More strokes of transparent color darken the face and the top of the big wave. And short, choppy strokes darken the faces of the distant waves to suggest the turbulent action of the water. So far, everything has been done with strokes of transparent color—just tube color and water.

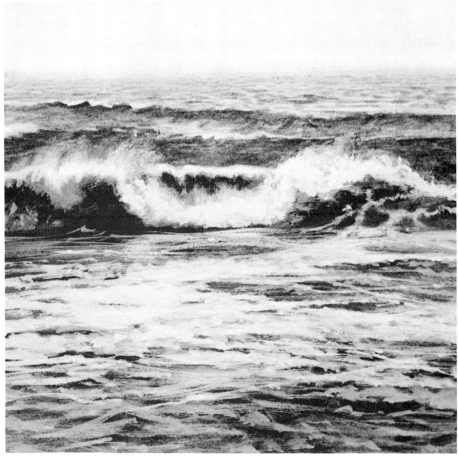

Step 4. In this final stage, the lighter tones of the foam are painted with strokes of opaque color, carried right over the transparent darks. The tube color contains plenty of white and only enough water or medium to make the paint creamy. The tip of the round brush traces horizontal lines of foam across the foreground, plus wandering lines of foam over the dark face of the big wave. The crashing surf is painted with thick, opaque white and so are the foamy tops of the distant waves. The shadows beneath the foam—which you can see most clearly at the left—are also opaque color, containing less white. Just as in nature, you have transparent water and opaque foam.

Step 1. This demonstration is painted on a sheet of cold pressed watercolor paper (called a "not" surface in Britain), which has an irregular texture that will hold the wet color in its peaks and valleys. After the clouds are drawn in pencil, the entire surface of the paper is brushed with clear water.

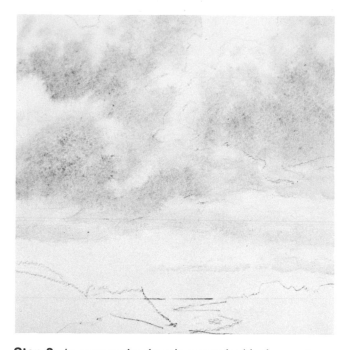

Step 2. As soon as the sheet is covered with clear water— and before the paper loses its shine—the shadow tones of the clouds are brushed in. When the strokes hit the paper, the color starts to spread and blur. The individual strokes disappear, leaving broad, soft tonal areas. Gaps of bare paper are left for the sunlit areas of the clouds.

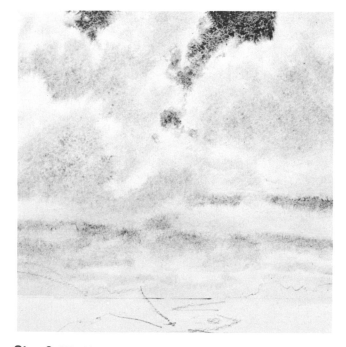

Step 3. Working quickly, while the painting surface is still wet and shiny, the brush adds the darker patches of sky that show through the clouds. The tip of the brush also adds the dark lines of the cloud layers just above the horizon. The paper is a bit drier than it was in Step 2, so these new strokes don't blur quite as much.

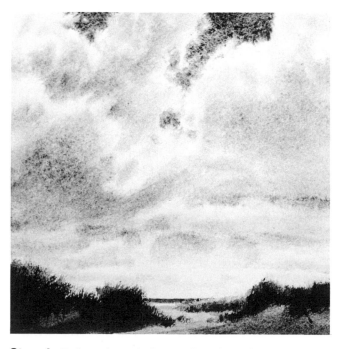

Step 4. Before the painting surface loses its shine completely, more dark strokes are added to the undersides of the clouds. Sunlit edges are lightened by blotting away color with a damp sponge, a damp softhair brush, or a paper towel. The landscape is completed in the drybrush technique, demonstrated later.

Step 1. Another way to create the soft edges of clouds (or foam) is the scumbling technique. Working with thick color, the brush moves back-and-forth with a scrubbing motion that blurs the strokes. This method works best with opaque color, so you can scumble light over dark, or dark over light. The pencil drawing, on a sheet of illustration board, defines the cloud shapes.

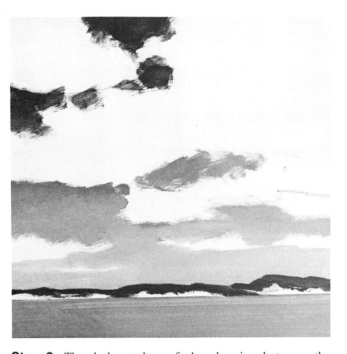

Step 2. The dark patches of sky showing between the clouds are painted first with thick, opaque color, darker at the top and lighter at the horizon. Notice that the scrubby, ragged strokes already suggest the soft edges of the clouds. The coast and water beneath are painted with smoother strokes of fluid color.

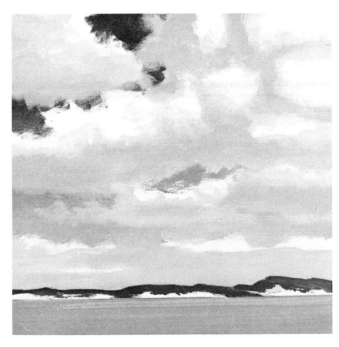

Step 3. The shadowy undersides of the clouds are scumbled with thick, opaque color, leaving bare painting surface for the sunlit areas. Once again, the scrubby strokes have ragged edges, so the shadows seem to melt into the lights.

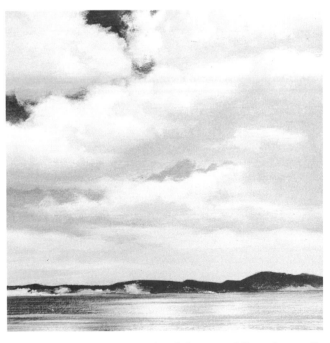

Step 4. The sky is completed by scumbling the sunlit planes of the clouds with soft, scrubby strokes that seem to blend into the shadows. Some of these strokes also overlap the dark patches of sky, which grow smaller as the clouds grow larger. The coastline and water are completed with the drybrush technique, demonstrated next.

Step 1. For rough, intricate textures, such as rocks or a pebbly beach, the drybrush technique is ideal. It's important to work on the textured surface of watercolor paper—cold pressed or rough—or possibly a sheet of illustration board or hardboard that's been coated with irregular brushstrokes of thick acrylic gesso. This demonstration is painted on a sheet of watercolor board, which means watercolor paper that's been mounted on thick cardboard by the manufacturer. The pencil drawing traces the contours of the rocks, but makes no attempt to indicate their texture, which will be left to the brush.

Step 2. A flat softhair brush is dampened with color and pulled horizontally across the distant water. Because the brush doesn't carry too much color, the tone isn't spread evenly over the painting surface. Instead, the brush tends to hit the peaks of the textured watercolor paper, skipping over many of the valleys, which remain white flecks. These flecks merge in the viewer's eye to look like ragged patches of foam. In the foreground between the rocks, the irregular texture of the sand is painted with quick touches of the damp brush. If the brush picks up too much color and starts to deposit solid tones rather than drybrush strokes, wipe the bristles on a paper towel or a sponge.

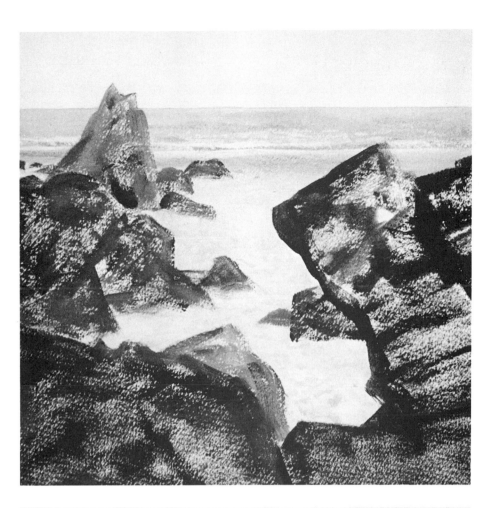

Step 3. Now you can see the drybrush strokes more distinctly in the rocks. The flat softhair brush picks up rich, dark color, but not too much. The damp brush moves over the painting surface without applying too much pressure, depositing color mainly on the high points. The low points of the painting surface remain bare. For the darker strokes, the brush picks up a little more color and presses harder, but the color is never fluid enough to cover the paper evenly. The rough pattern of dark and light flecks expresses the rugged character of the rocks.

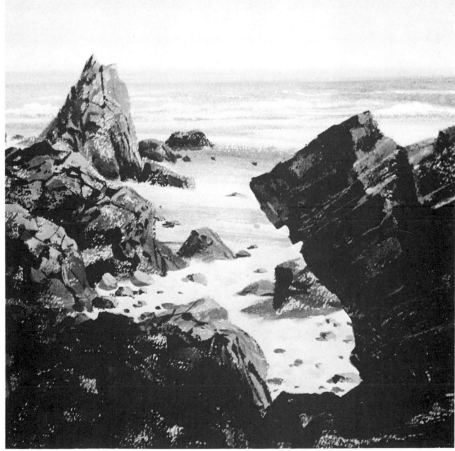

Step 4. The rocks are completed with drybrush strokes of thick color: light strokes for the sunlit planes and darker strokes for the shadows. The brush is dragged and skimmed over the paper, which breaks up the stroke into ragged flecks. It's hard to find a smooth, even tone here. More horizontal strokes of pale foam are drybrushed over the distant sea. Finally, the tip of a round softhair brush picks up some fluid color for the precise finishing touches: the cracks in the rocks, and some pebbles and their shadows. Drybrush works equally well with opaque or transparent color; try them both.

Brushes. Because you can wash out a brush quickly when you switch from one color to another, you need very few brushes for acrylic painting. Two large flat brushes will do for covering big areas: a 1″ (25 mm) bristle brush, the kind you use for oil painting; and a softhair brush the same size, whether oxhair, squirrel hair, or soft white nylon. Then you'll need another bristle brush and another softhair brush, each half that size. For more detailed work, add a couple of round softhair brushes—let's say a number 10, which is about 1/4″ (6 mm) in diameter, and a number 6, which is about half as wide. If you find that you like working in the transparent technique, which means thinning acrylic paint to the consistency of watercolor, it might be helpful to add a big number 12 round softhair brush, either oxhair or soft white nylon. Since acrylic painting will subject brushes to a lot of wear and tear, few artists use their expensive sables.

Painting Surfaces. If you like to work on a smooth surface, use illustration board, which is white drawing paper with a stiff cardboard backing. For the transparent technique, the best surface is watercolor paper—and the most versatile watercolor paper is mouldmade 140 pound stock in the cold pressed surface (called a "not" surface in Britain). Acrylic handles beautifully on canvas, but make sure that the canvas is coated with white acrylic paint, not white oil paint. Your art supply store will also sell inexpensive canvas boards—thin canvas glued to cardboard. These are usually coated with white acrylic, which is excellent for acrylic painting. You can create your own painting surface by coating hardboard with acrylic gesso, a thick, white acrylic paint which comes in cans or jars. For a smooth surface, brush on several thin coats of acrylic gesso diluted with water to the consistency of milk. For a rougher surface, brush on the gesso straight from the can so that the white coating retains the marks of the brush. Use a big nylon housepainter's brush.

Drawing Board. To support your illustration board or watercolor paper while you work, the simplest solution is a piece of hardboard. Just tack or tape your painting surface to the hardboard and rest it on a tabletop—with a book under the back edge of your board so it slants toward you. You can tack down a canvas board in the same way. If you like to work on a vertical surface—which many artists prefer when they're painting on canvas, canvas board, or hardboard coated with gesso—a wooden easel is the solution. If your budget permits, you may like a wooden drawing table, which you can tilt to a horizontal, diagonal, or vertical position just by turning a knob.

Palette. One of the most popular palettes is the least expensive—just squeeze out and mix your colors on a white enamel tray, which you can probably find in a shop that sells kitchen supplies. Another good choice is a white metal or plastic palette (the kind used for watercolor) with compartments into which you squeeze your tube colors. Some acrylic painters like the paper palettes used by oil painters: a pad of waterproof pages that you tear off and discard after use.

Odds and Ends. For working outdoors, it's helpful to have a wood or metal paintbox with compartments for tubes, brushes, bottles of medium, knives, and other accessories. You can buy a tear-off paper palette and canvas boards that fit neatly into the box. Many acrylic painters carry their gear in a toolbox or a fishing tackle box, both of which also have lots of compartments. Two types of knives are helpful: a palette knife for mixing color; and a sharp one with a retractable blade (or some single-edge razor blades) to cut paper, illustration board, or tape. Paper towels and a sponge are useful for cleaning up—and they can also be used for painting, as you'll see later. You'll need an HB drawing pencil or just an ordinary office pencil for sketching in your composition before you start to paint. To erase pencil lines, get a kneaded rubber (or "putty rubber") eraser, which is so soft that you can shape it like clay and erase a pencil line without abrading the surface. To hold down that paper or board, get a roll of 1″ (25 mm) masking tape and a handful of thumbtacks (drawing pins) or pushpins. To carry water when you work outdoors, you can take a discarded plastic detergent bottle (if it's big enough to hold a couple of quarts or liters) or buy a water bottle or canteen in a store that sells camping supplies. For the studio, find three wide-mouthed glass jars, each big enough to hold a quart or a liter.

Work Layout. Before you start to paint, lay out your supplies and equipment in a consistent way, so everything is always in its place when you reach for it. Obviously, your drawing board or easel is directly in front of you. If you're right-handed, place your palette, those three jars, and a cup of medium to the right. In one jar, store your brushes, hair end up. Fill the other two jars with clear water: one is for washing your brushes; the other provides water for diluting your colors. Establish a fixed location for each color on your palette. One good way is to place your *cool* colors (black, blue, green) at one end and the *warm* colors (yellow, orange, red, brown) at the other. Put a big dab of white in a distant corner, where it won't be fouled by the other colors.

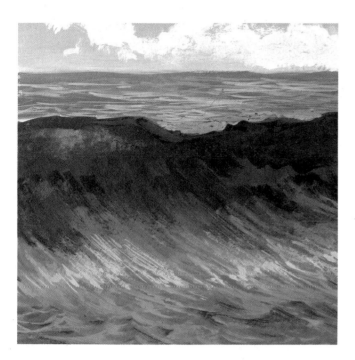

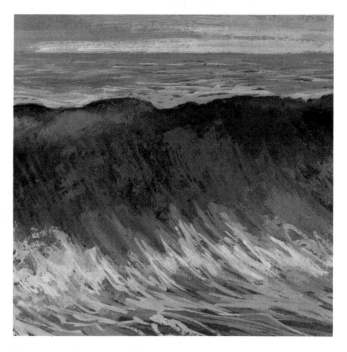

Wave on Sunny Day. Because the sea is essentially a reflecting surface, its color is strongly influenced by the weather and by the prevailing light. On a sunny day, you'll see bright blues and greens. The shadowy face of the wave, curving upward and tipping over slightly so it doesn't catch the direct sun, looks transparent and lets the light shine through.

Wave on Overcast Day. On a gray, overcast day, that same wave looks quite different. The water picks up the grayish tone of the sky. The shadowy face of the wave seems less transparent. However, the water is far from a dead, uniform gray. It's still full of color, but much more subtle color than you see on a sunny day.

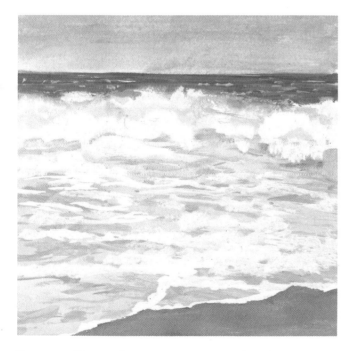

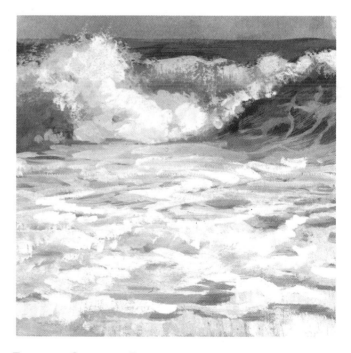

Foam on Sunny Day. Foam is water in a different form, but it's still a reflecting surface, affected by light and weather. On a sunny day, the foam reflects the golden warmth of the sun's rays. The sea beyond reflects the bright, cool tones of the sky. As the foam spills forward over the beach, the sandy tone shines through.

Foam on Overcast Day. When clouds cover the sky and block off the sun, the light loses its warm tone and turns grayish. The foam reflects this cool light, just as the water reflects the more somber tone of the sky. The beach looks grayer too, and these subdued sandy tones shine through the foam as it moves across the beach.

Clear Sky. On a sunny day, a cloudless sky is a deep, rich blue, but it's not a smooth, consistent tone from top to bottom. It's usually darkest at the zenith and grows lighter toward the horizon. Your two blues, phthalocyanine and ultramarine, plus white, will make a lovely sky tone. As you approach the horizon, you can add more white plus yellow ochre for a hint of warmth.

Overcast Sky. An overcast sky is actually full of subdued colors. Notice how these cloud layers are sometimes warm, sometimes cool. Try mixing blues and browns—ultramarine or phthalocyanine with burnt umber or burnt sienna—in different proportions to get blue-grays and brown-grays. Naturally, you'll need some white. And add yellow ochre for a more golden tone.

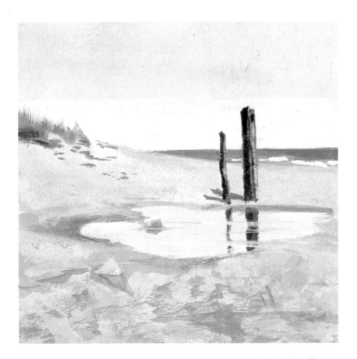

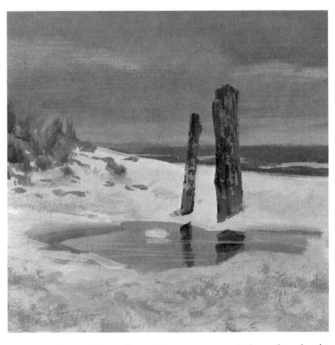

Tidepool on Clear Day. A tidepool usually looks like a patch of sky dropped onto the beach. On a sunny day, the pool mirrors the clear, bright tones of the sky overhead. Notice that the pool also reflects nearby objects like these two weathered wooden posts. The wind produces light and dark ripples that interrupt the reflections.

Tidepool on Gray Day. On an overcast day, the sky is often darker than the beach—and so is the tidepool. The shadowy tones of the sky are mirrored in the water, where the reflections of the wooden posts look darker too. Where a little light breaks through the sky, as it does on the left, this light reappears in the pool.

Dry Rocks. When you're painting coastal scenery, remember that the same subject can change radically in color, depending upon whether it's dry or wet. These dry rocks have warm, sunny tones on their sunlit sides. The shadow sides are darker—picking up warm reflections from the sand and cool reflections from the sky—but not nearly as dark as they'll be when the rocks are wet.

Wet Rocks. When the waves splash over these rocks, the color grows deeper and more intense. Now the rock is a bright, reflecting surface. The sunlit sides grow brighter and warmer, bouncing back the warm rays of the sun and also picking up some cool reflections from the water. The shadow sides become dark and glistening, but they too pick up cool reflections from the water.

Sand Dunes. Even on the sunniest day, sand isn't a bright, golden tone, but tends toward a very subtle yellowish tan. In the shadows, the sand is a much cooler tone—as close to gray as it is to tan. The lighted planes seem to reflect sunlight, while the shadows seem to pick up some of the cooler tone of the sky.

Headlands. Rocky headlands, near and far, are a good example of color perspective. The near headland is both darker and brighter, with stronger contrasts between the lights and shadows, than the far headland, which is paler, more subdued, and distinctly cooler in color, with much less contrast between the lights and shadows.

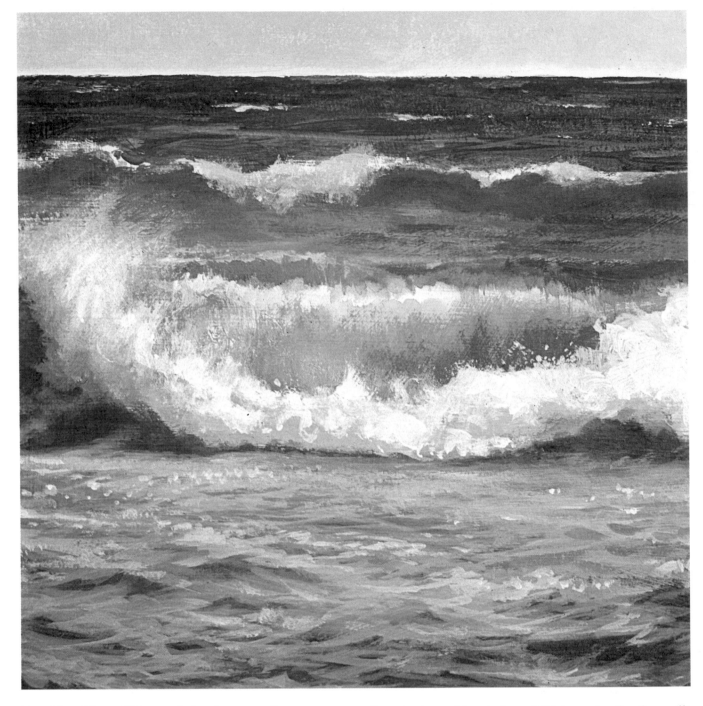

Breaking Wave. This actual size close-up—from a much larger painting—shows a variety of brushstrokes used to paint the action of a breaking wave and the surrounding water. The water in the foreground is painted with short, curving, arc-like strokes that capture the rippling movement. This foreground is painted from dark to light: dark strokes first; lighter strokes on top of these dark strokes; and lightest strokes last. The crashing foam is painted in two operations: first the smooth tone of the underlying shadow; then short, scrubby strokes of thicker color for the sunlit areas. The downward curve of the clear water directly behind the foam is painted with vertical, scumbling strokes that suggest the downward movement of the breaking wave. The flying foam at the left is lightly drybrushed over the dark background. The little blobs of foam that float over the foreground, as well as the flecks that are flung up by the crashing surf, are painted with tiny touches of the tip of the brush.

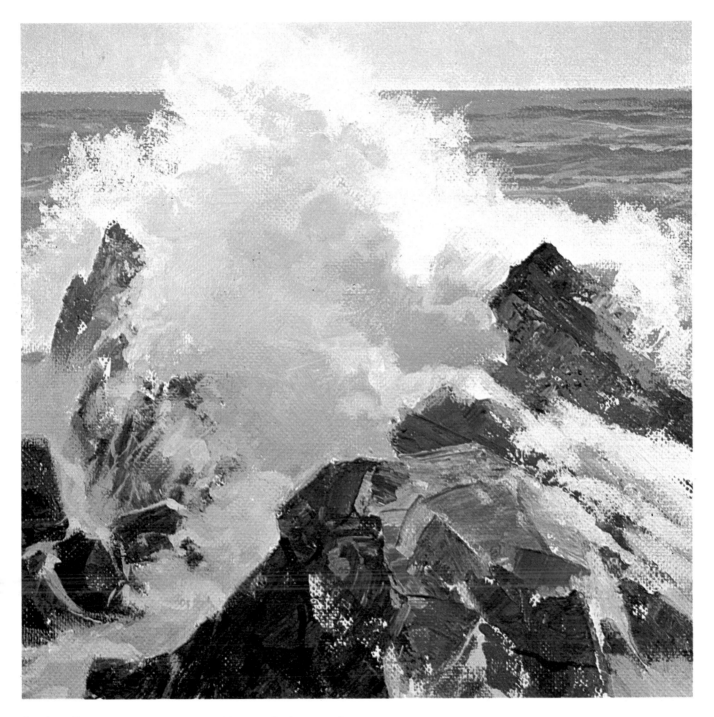

Surf on Rocks. This exploding surf is a particularly good example of scumbling. Within the shadow of the foam, you can see each individual scrub of the brush merging softly with the next stroke. One wet stroke is placed beside another, and they're lightly scrubbed together without merging completely. The sunlit edge of the foamy shape is scumbled with lighter color that blurs against the sky rather than forming a hard edge. In contrast with the soft brushwork of the surf, the rocks are painted with broad, flat, hard-edged strokes of the painting knife. Each stroke stands out sharply to make the rocks look blocky. Then more foam is scumbled over the dry knife strokes.

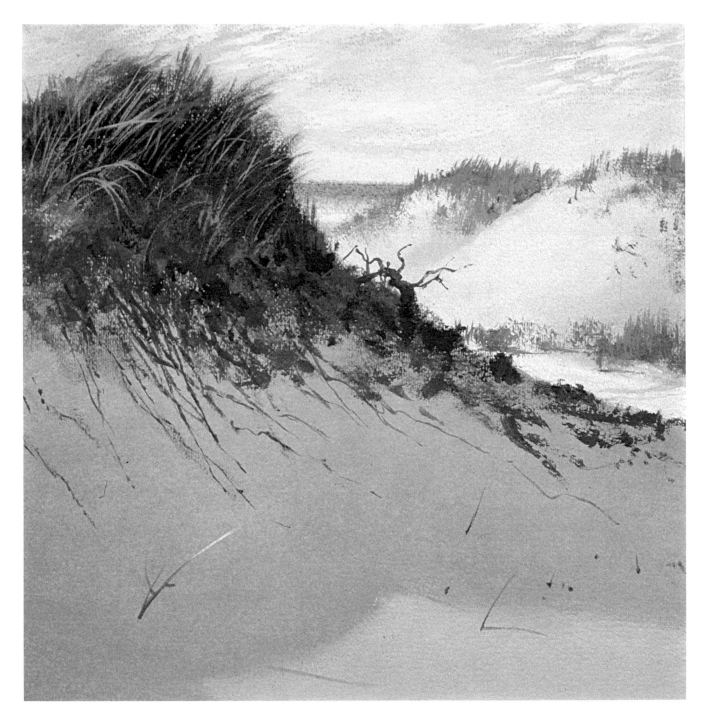

Dunes and Beach Grass. The soft tones of the sand are painted with thin, fluid color, smoothly applied with a soft-hair brush that irons out and blends the individual strokes into continuous tones. The individual strokes are invisible, fusing softly into one another. In contrast to these smooth tones, the beach grass at the tops of the dunes is painted with clearly defined brushwork. On the big dune to the left, dark tones are first applied with drybrush strokes of thick color, broken up by the texture of the watercolor paper. Then the tip of a round softhair brush carries dark strands of this tone downward over the dune. The same brush adds crisp, curving, individual strokes on top of the dark undertone to suggest blades of grass. The sparse beach grass on the more distant dunes is suggested by slender drybrush strokes made with the tip of the brush.

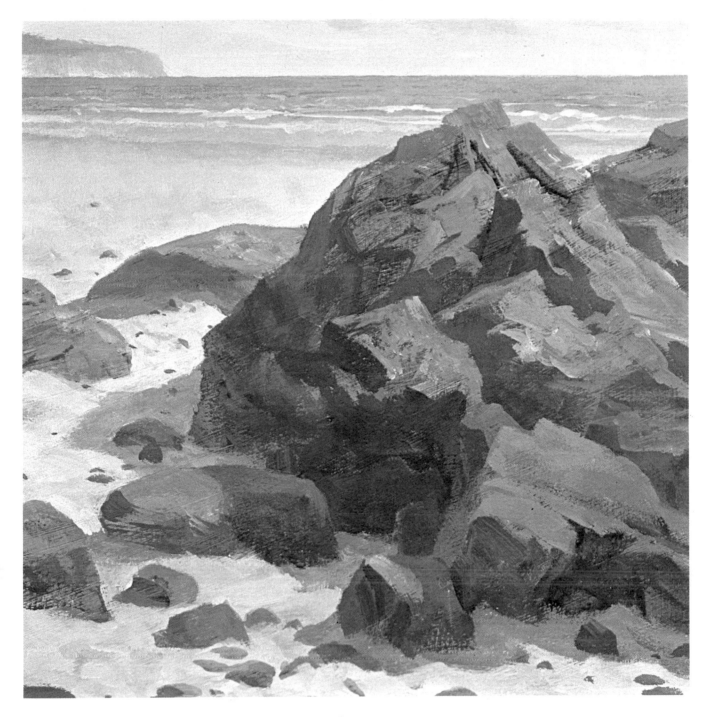

Rocks on Beach. The heavy, roughly textured forms of the rocks are painted with thick color on watercolor paper that adds its own texture to that of the paint. A flat brush lays thick strokes side-by-side, one wet stroke overlapping another, to cover the sunlit tops of the rocks. The strokes follow the diagonal tilt of the rocks. Then the same brush paints the shadowy sides of the rocks with straight, squarish strokes of thick color. The sand is painted with smoother, more fluid color, which grows smoother and more liquid as the beach approaches the water. The consistency of the paint matches the subject. It's usually a good idea to concentrate your thickest paint and your roughest brushwork in the foreground, using thinner, smoother paint in the distance.

Step 1. The horizon line, the horizontal lines of the distant waves, the curving shapes of the closer waves and foam, and the low waves in the foreground are all drawn in pencil on a sheet of hardboard. The board has been coated with two layers of acrylic gesso diluted with water to the consistency of thin cream. One coat is brushed from top to bottom and allowed to dry. And the other coat is brushed from side to side. This produces a subtle crisscross pattern, something like canvas.

Step 2. A kneaded rubber eraser (called putty rubber in Britain) lightens the pencil lines so that they're almost invisible here. Then a semi-transparent mixture of chromium oxide green, phthalocyanine blue, and just a hint of white is freely brushed over the entire sea, starting from the horizon and working down to the bottom of the picture, leaving bare gesso only for the surf. This mixture is lightened with water at the top of the big wave. The brushstrokes in the immediate foreground are a bit darker, and they curve to suggest the wave action. Then the distant sea is darkened with horizontal strokes of ultramarine blue, Hooker's green, and a little white.

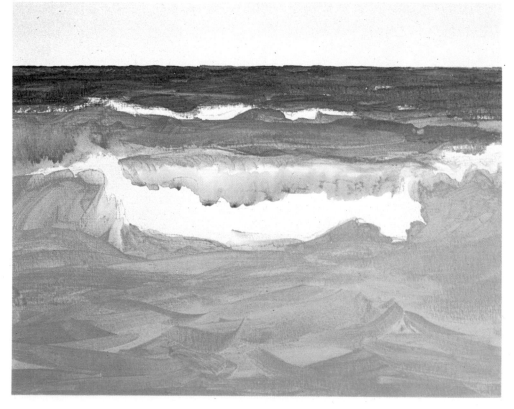

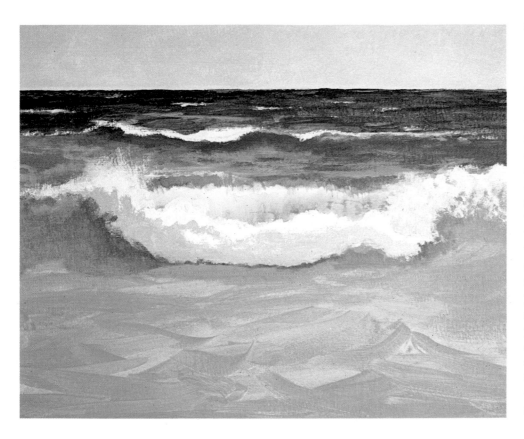

Step 3. The sky is brushed with a smooth mixture of phthalocyanine blue, napthol crimson, yellow ochre, and white. The distant sea and the strip of water behind the near wave are darkened with horizontal strokes of phthalocyanine blue, chromium oxide green, burnt sienna, and white. A few whitecaps are added to the distant water with touches of white tinted with sky tone. The shadow on the foam is painted with the sky mixture, and then the sunlit edge is painted with pure white tinted with a little sky mixture and some more yellow ochre. The face of the oncoming wave is darkened at the left with the same mixture—but containing more white—that's used for the distant sea.

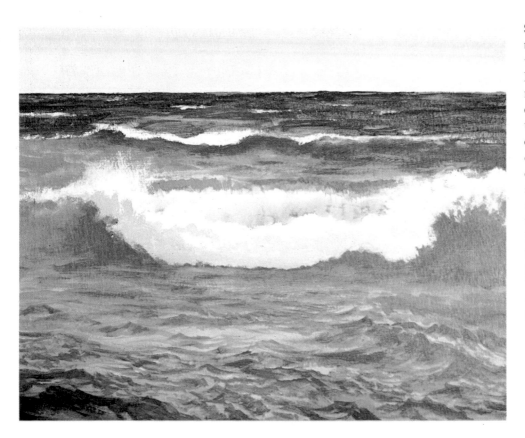

Step 4. Work now begins on the details of the rippling water in the foreground. Phthalocyanine blue, chromium oxide green, burnt sienna, and a little white are thinned with water to a fluid consistency necessary for precise brushwork. Then the tip of a round softhair brush strikes in short, curving strokes to suggest the dark faces of the ripples. The brush leaves spaces between these strokes, allowing the undertone to shine through. The face of the oncoming wave is darkened at right with this fluid mixture.

Step 5. The tops of the foreground ripples, which reflect the pale tone of the sky, are painted with a round softhair brush. This light tone is a mixture of phthalocyanine blue, chromium oxide green, yellow ochre, and white. The color is slightly thicker and more opaque than the dark undertone. Once again, the strokes are short curves, which you can see most clearly in the immediate foreground. These strokes don't cover the foreground completely, but leave gaps for the dark undertone to shine through. This mixture is carried upward over the face of the oncoming wave—to the right and left of the exploding surf—to suggest foam trickling over the clear water.

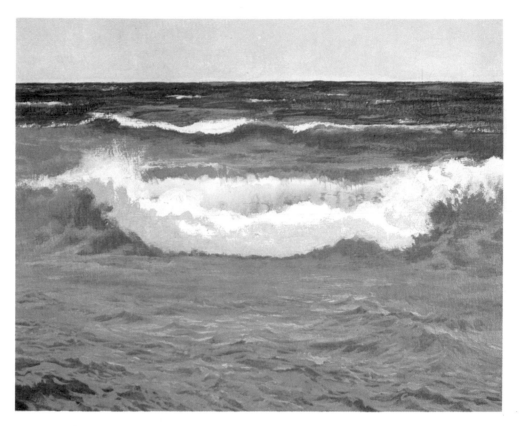

Step 6. The details of the foreground are completed with the tip of a small round brush that carries the same colors that are used in Step 5—but the mixture is lightened with more white. Curving strokes of this mixture suggest the light on the tops of the ripples. Then the brush picks up almost pure white, faintly tinted with sky tone, and adds touches of foam to the tops of the foreground waves. The brush also adds trails and flecks of foam that wander from left to right across the foreground. Once again, all these strokes are spaced out to allow the underlying darker strokes to come through. An intricate pattern of strokes suggests the sparkle and the action of the water.

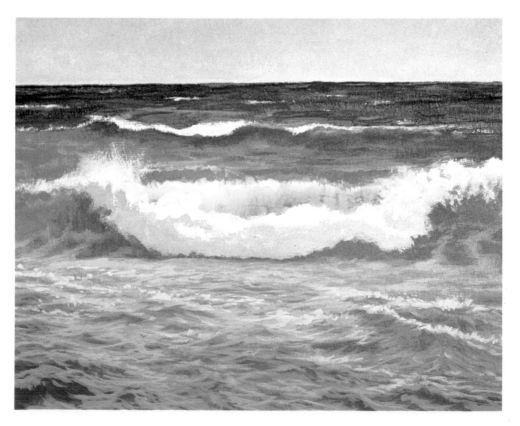

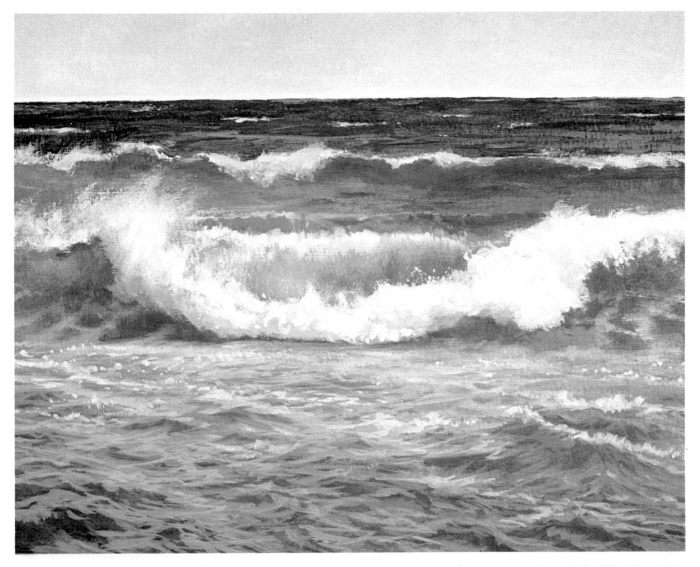

Step 7. The brush strengthens the tone of the wave that rolls downward behind the crashing foam. Darker tones of phthalocyanine blue, naphthol crimson, yellow ochre, and white are scumbled directly behind the foam to give the curving wave a more three-dimensional, barrel shape. Pure white tinted with a little sky tone is scumbled along the top of the barrel. Now there's a clear gradation from light to middletone to shadow, giving the wave a distinctly round shape. A bristle brush scumbles a thick mixture of white tinted with sky tone and a little more yellow ochre over the sunlit edge of the surf. These scumbling strokes cover some of the shadow tone that first appeared on the surf in Step 3.

At the extreme left, the face of the big wave is scumbled with a pale mixture of phthalocyanine blue, Hooker's green, and white, to suggest light breaking through the transparent water. More of the foam mixture is scumbled along the foamy edge of the more distant wave. A mixture of phthalocyanine blue, chromium oxide green, yellow ochre, and white is carried across the distant sea in horizontal drybrush strokes to suggest lighter tones on the water. Finally, the tip of a small brush adds some tiny dots of pure white to suggest foam flying upward from the crashing surf of the big wave.

Step 1. This study of surf and rocks will be painted on canvas whose texture is a bit too rough for pencil drawing. So the preliminary drawing is done on a sheet of transparent tracing paper. This smooth paper allows you to erase easily, which means that you can change your mind and redraw the lines until you get them right. When the drawing seems accurate, a second sheet of tracing paper is scribbled with soft pencil or charcoal. This transfer paper, as it's called, is laid over the canvas, and the drawing is laid on top. A sharp pencil goes over the most important lines of the drawing, which are then imprinted on the canvas via the transfer paper.

Step 2. The lines registered by the tracing paper are thinner, lighter, and simpler than the original drawing. Ultramarine blue, burnt sienna, yellow ochre, and white—straight from the tube—are mixed on the palette with the painting knife. The colors aren't smoothly blended. The mixture is lighter in some areas, darker in others. The knife picks up some dark tone on the underside of the blade and spreads this thick paste over the canvas with short, decisive strokes to suggest the shadows of the rocks. Then the knife picks up some lighter tones and spreads them over the darks to suggest the sunlit tops.

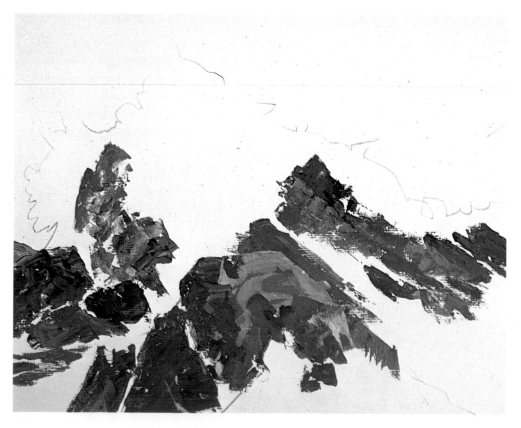

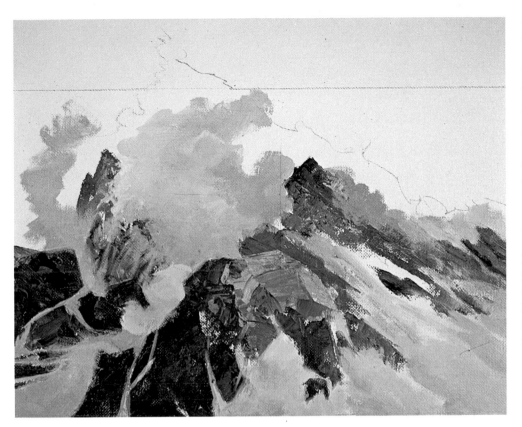

Step 3. The shadows of the crashing foam are scumbled with a stiff bristle brush that carries a mixture of ultramarine blue, naphthol crimson, yellow ochre, and white. The color is thick and creamy. One wet stroke is scrubbed into and over another, so they merge slightly, although you can still see the individual strokes. By now, the knife strokes are dry and brushstrokes of this foamy mixture are carried over and between the rocks to suggest foam splashing and running over the dark, blocky shapes. Notice the lines of foam running through the cracks in the rocks at the lower left.

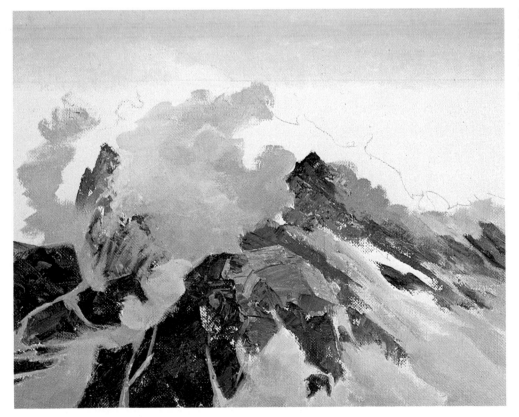

Step 4. The sky tone is painted with a smooth, fluid mixture of ultramarine blue, naphthol crimson, yellow ochre, and white, carried down to the horizon line.

Step 5. A darker mixture of the sky tone—ultramarine blue, naphthol crimson, yellow ochre, and white—covers the sea, leaving a ragged strip of bare canvas for the sunlit edge of the foam. This mixture is darkest at the horizon and grows slightly lighter—containing more white—as it moves forward toward the rocks. The color is smooth and fluid enough to paint a crisp horizon line. Yet the color is thick enough to scumble around the edge of the foam, which is soft and ragged.

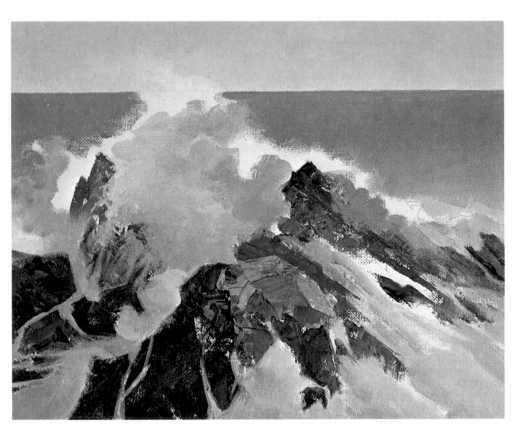

Step 6. When the underlying tone of the sea is dry, the point of a round softhair brush defines the darks and lights of the distant waves. The dark, horizontal lines are a mixture of ultramarine blue, a little naphthol crimson, some yellow ochre, and less white than the undertone. These strokes eliminate some of the foam at the extreme left. Then a lot of white is added to this mixture to paint the line of foam on the distant wave, just below the horizon, as well as the line of foam just above the rocks at the left. Now the canvas is almost completely covered with color, except for the sunlit edge of the exploding foam and some strips of sunlight on the foam that runs over the rocks.

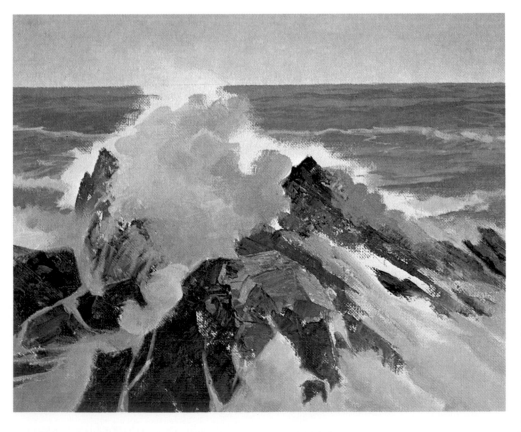

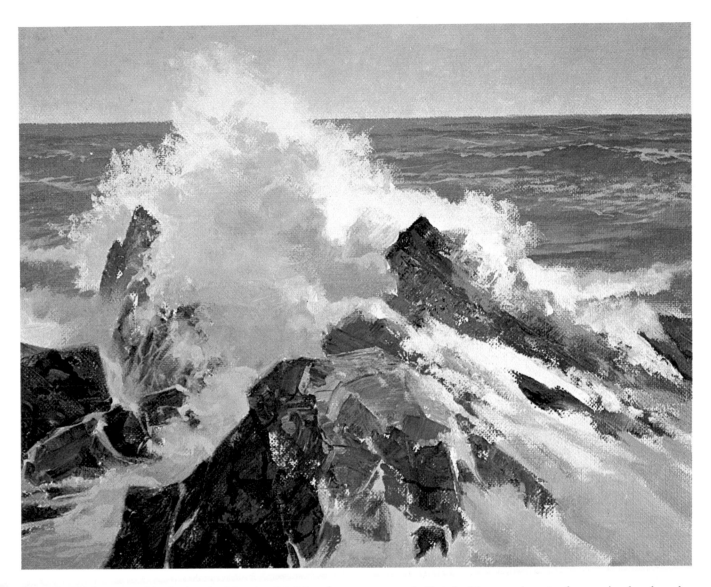

Step 7. Thick, pure white is tinted with a touch of the sky mixture and scumbled over the bare canvas around the edge of the foam that leaps up from the rocks. The brush scrubs back-and-forth to create a soft transition where the sunlit area melts into the shadow. Where the foam stands out against the dark sea beyond, the tip of the bristle brush applies the pale color in quick dabs that are broken up by the texture of the canvas. (Canvas is particularly receptive to scumbling because the fibers of the woven cloth have a lovely way of softening the stroke.) The bristle brush drags this thick, sunny mixture downward to the right, suggesting sunlight shining on the foam that runs over the rock formation. Then this pale mixture is darkened with a bit more sky tone and diluted with enough water for precise brushwork. So far, everything has been done with bristle brushes; but now a round softhair brush picks up this pale, fluid mixture and traces the lines of the foam on the distant sea with slender strokes. Moving into the foreground, the brush draws more trickles and streaks of foam over the rocks that are disappearing under the mass of surf. These trickles of foam are carried between the rocks and down into the lower left corner. This seascape shows the importance of finding the right tool for the subject: the painting knife for the rocks; the bristle brush for the waves and surf; and the softhair brush for the final details.

Step 1. Watercolor paper has a tender surface that won't take too much erasing when you're working out your composition with the pencil. So the complex forms of this rocky coast are first drawn on tracing paper and then transferred to the sheet of watercolor paper by the same method used in Demonstration 2. In transferring a drawing to watercolor paper, don't press too hard on the point of the pencil—you'll leave grooves in the sheet. Press just hard enough to leave a pale line.

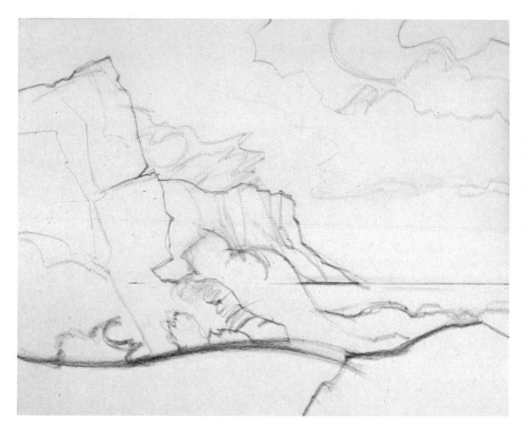

Step 2. When you're painting a stormy sky, it's important to decide just how dark that sky ought to be. If it's too light, it won't look stormy enough. But if it's too dark, you won't be able to see the shapes of the landscape below. So this painting begins with two dark areas of the landscape: the very dark tone on the tall cliff and the slightly lighter tone on the headland beyond. Now, when the dark sky is added, it will be easier to establish the right tone by comparing the sky with the rocky shapes. The darks of the rocks are a mixture of ultramarine blue and burnt sienna, which make a blackish tone that's more interesting than a simple mixture of mars black and water.

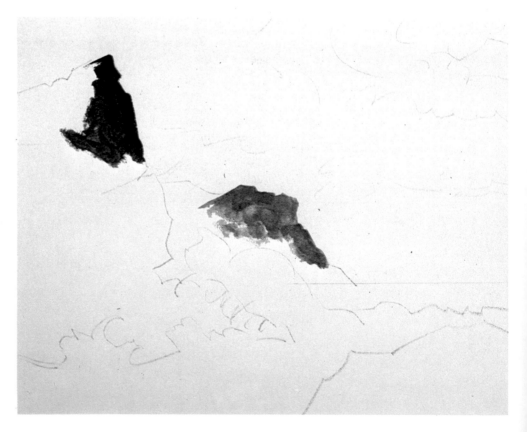

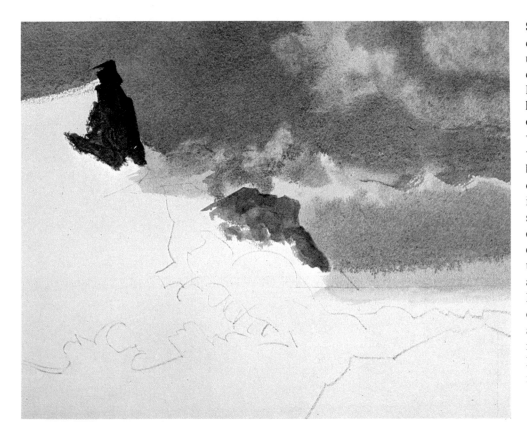

Step 3. The sky area is covered with a pale wash of ultramarine blue, naphthol crimson, yellow ochre, and lots of water. Now the sky has a faint tone over it, just one step removed from clear white. While this wash is still wet and shiny, the brush goes back in with a darker version of this same mixture containing less water. These dark strokes spread and blur to become the dark shapes of the clouds. A gap is left across the center of the sky and across the horizon to suggest light breaking through the clouds. A paper towel blots away some color at the upper right and just above the headland to suggest more breaks in the clouds.

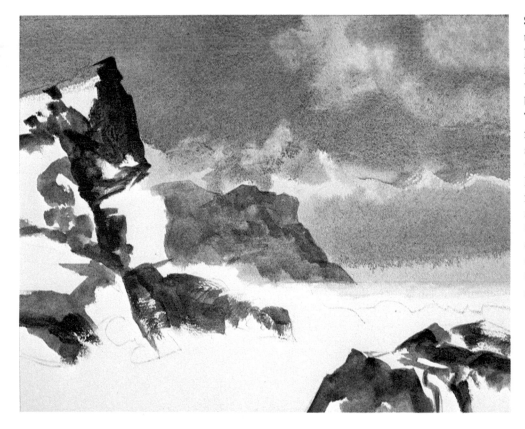

Step 4. The dark shapes of the cliff and headland at the left, plus the rock formation in the lower right, are painted with strokes of ultramarine blue, burnt sienna, and water. This is the same mixture that first appeared in Step 2. The squarish strokes are made with a flat softhair brush, leaving gaps of white paper for the lighter tones that will appear on the rocks later. Only the distant headland is completely covered with this color, containing more water to make the shapes seem paler and more distant.

Step 5. When the shadow tones of Step 4 are dry, more water is added to the same mixture of ultramarine blue and burnt sienna. Then this transparent tone is washed over the big cliff at the left and the rocks at the lower right. This transparent wash darkens the shadows and solidifies the shapes by giving them an overall tone. On a dark, stormy day, even the lighted areas of the rocks are quite dark.

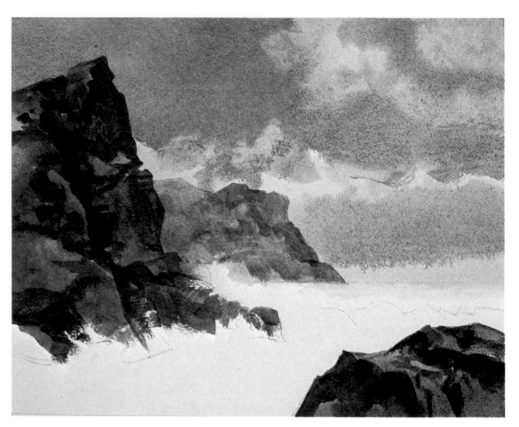

Step 6. The sea beneath the stormy sky must match the somber tones overhead. So the water is painted in transparent strokes of ultramarine blue, naphthol crimson, yellow ochre, and water. The distant water is painted in horizontal strokes that stop at the patch of bare paper that's left for the foam crashing against the rocks. Then, in the foreground, the water is painted with shorter strokes that curve to match the movement of the incoming waves. Another transparent wash of ultramarine blue, burnt sienna, and water is carried over the distant headland, the cliff, and the rock formation at lower right, making them darker and more powerful.

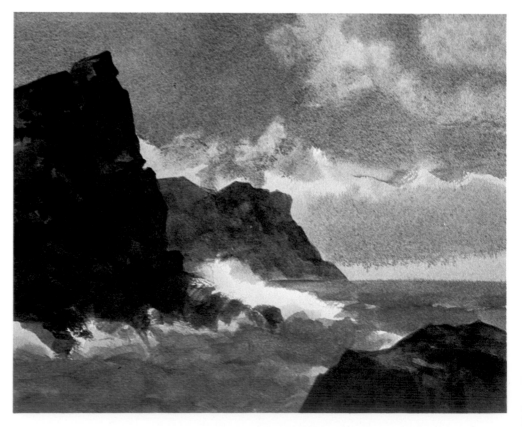

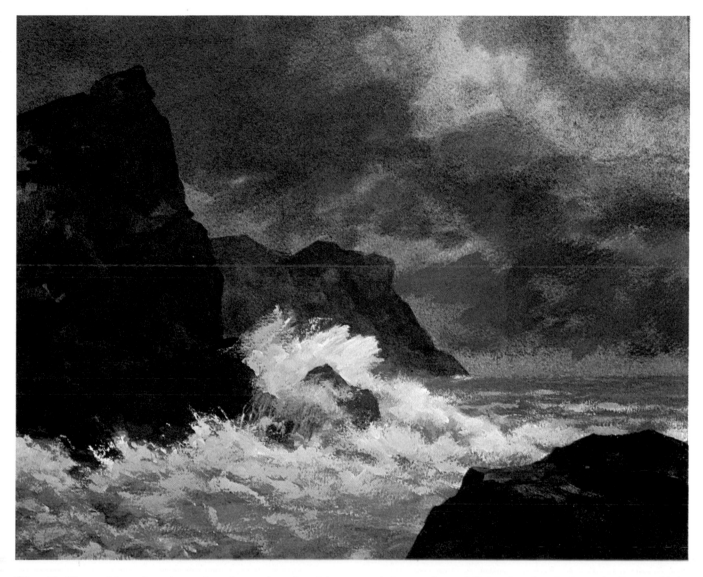

Step 7. Up to this point, the entire picture is painted in transparent color diluted only with water. No white has been added to make the color lighter or more opaque. Now the final touches are added with opaque color. The sky is brushed with clear water. While the surface is still wet, a bristle brush adds opaque strokes of ultramarine blue, naphthol crimson, yellow ochre, and white. These strokes blur on the wet surface, but the color is thick, and they don't blur quite as much as the strokes of transparent color in Step 3. Now there's a stronger contrast between the dark clouds and the patches of light that break through. Pure, thick white is lightly tinted with the water mixture, then diluted to a creamy consistency. This luminous white is scumbled at the foot of the cliff to indicate foam crashing against the rocks. Individual strokes of this mixture are drybrushed in the foreground to indicate more wave action. And more strokes are drybrushed over the distant sea to suggest the foamy tops of oncoming waves. This moody, atmospheric seascape is a particularly effective combination of fluid, transparent color and thick, opaque color.

Step 1. The effects of moonlight are so subtle that it's very difficult to capture them with pencil lines. All the pencil can do is draw the line of the horizon, the line of the beach, the silhouette of the distant shore, the jagged shape of the reflection on the water, plus the circle of the moon and a few rocks on the sand. The brush will have to do the work of defining the soft shapes of the moonlit clouds. The painting is done on a sheet of illustration board.

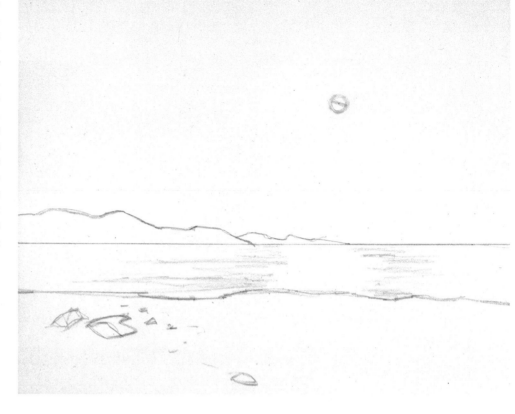

Step 2. The picture is painted from dark to light, starting with the most somber tones. The entire painting surface is covered with smooth, fluid strokes of ultramarine blue, burnt sienna, yellow ochre, and a touch of white for opacity. A little more white and some more water are added at the lower edge of the sky to suggest the glow at the horizon. Only the moon and its reflection remain bare paper. Then the reflection is slightly tinted with the sky mixture and lots of water.

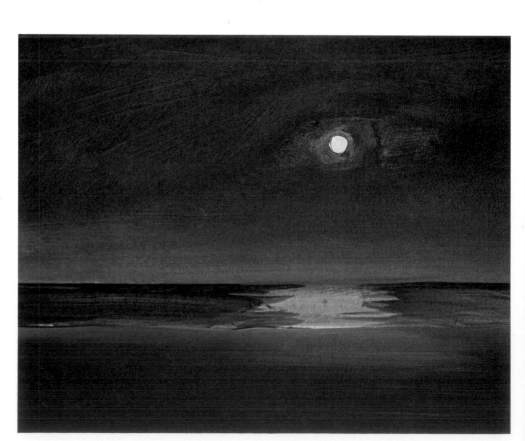

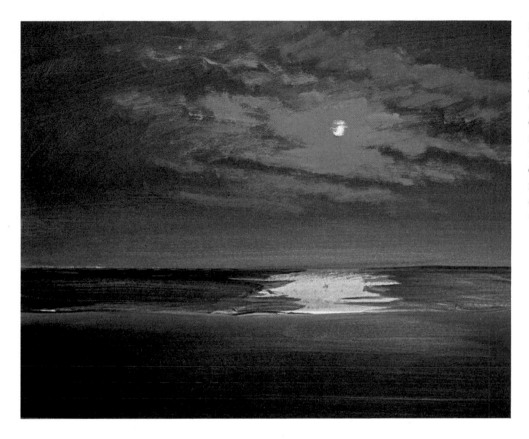

Step 3. The moonlit clouds are scumbled over the sky with phthalocyanine blue, naphthol crimson, yellow ochre, and white. Look closely and you'll see that the clouds are all painted with short, straight, parallel strokes that move diagonally downward from the upper right. The moon is partly covered by these strokes but will be reestablished later on.

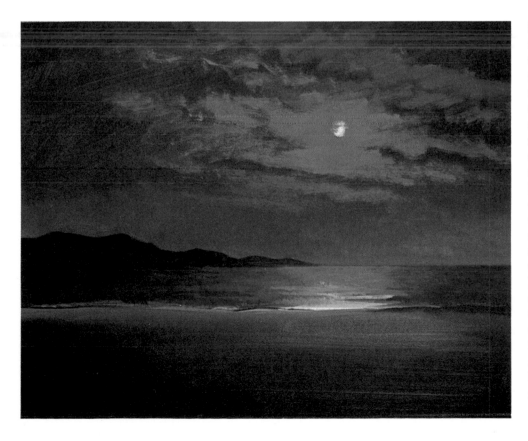

Step 4. To intensify the glow in the lower sky, a hint of this cloud mixture is scumbled upward from the horizon. The dark shape of the distant shore is painted with a smooth mixture of ultramarine blue, burnt sienna, and a touch of white. The cloud mixture, containing a little more blue, is scumbled downward from the horizon to cover most of the moon's reflection in the water. On each side of this reflection, the water is darkened with horizontal, scumbled strokes of the original sky mixture: ultramarine blue, naphthol crimson, and yellow ochre. A bit of the cloud mixture is scumbled over the edge of the beach at the left to suggest moonlight on wet sand.

Step 5. The original tone of the sky is darkened and solidified with a dense, creamy, opaque mixture of ultramarine blue, naphthol crimson, and yellow ochre, smoothly brushed with a flat softhair brush. This mixture covers some of the clouds and provides a dark background for more luminous tones that will be added to the sky in the final step. The moon's reflection is now re-established with a mixture that consists mainly of white plus some sky color. The reflection actually consists of small touches of color applied in rows with the tip of a bristle brush. These touches give the feeling that the moon is shining on the tops of waves that are moving into shore.

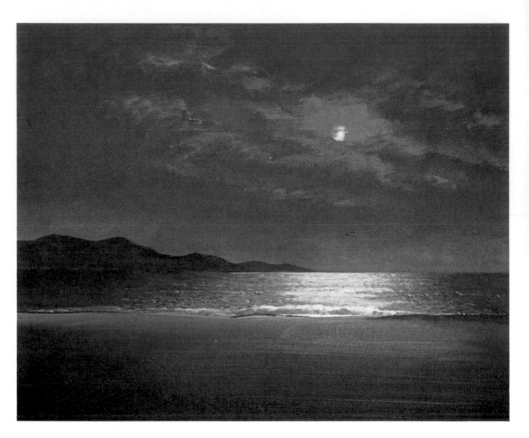

Step 6. The moonlit tops of the rocks on the beach are painted with short, smooth strokes of ultramarine blue, naphthol crimson, yellow ochre, and enough white to make them stand out in the darkness. The shadow sides of the rocks are scumbled with this same mixture, but containing no white. Then a little white is added to the mixture, which is then scumbled over the beach to give the sand a dark, unified tone. The moonlight mixture (from Step 5) is scumbled along the edge of the beach to suggest light reflecting on the wet sand.

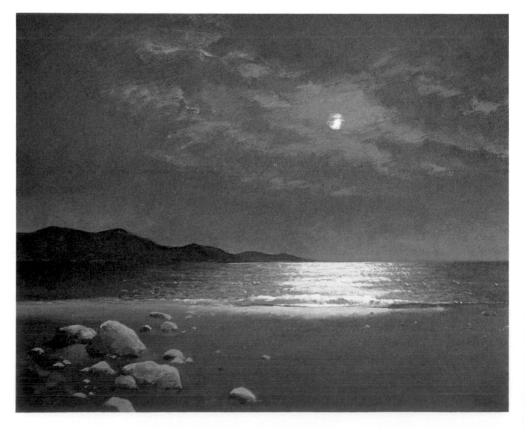

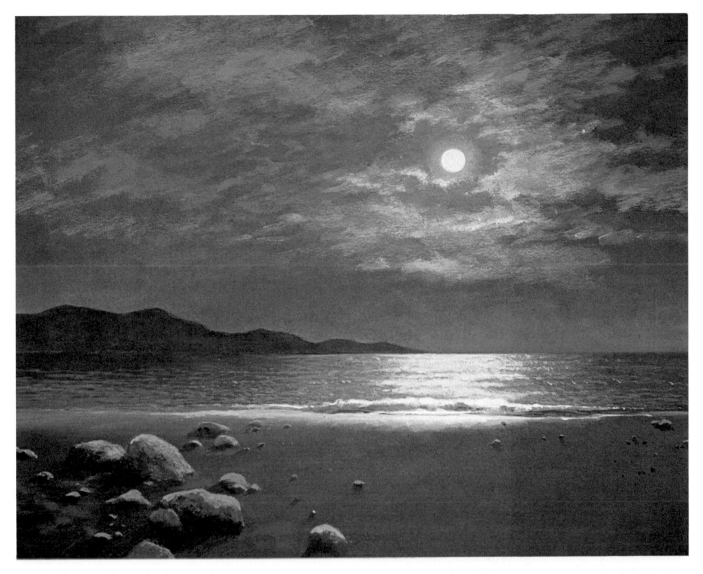

Step 7. The clouds, which seemed too insistent, were cut back in Step 5. Now they're painted in a much darker, more subdued tone and carried across most of the sky. This is a dark mixture of ultramarine blue, naphthol crimson, yellow ochre, and just enough white to make them stand out against the dark background. As you saw in Step 3, the clouds are painted with short, straight, parallel strokes that move diagonally downward from right to left. Now more white, naphthol crimson, and yellow ochre are added to this mixture and scumbled over the edges of the clouds that are closest to the moon. The same mixture is used to scumble the halo around the moon. The circle of the moon is repainted with almost pure white, tinted with a touch of this mixture.

On either side of the reflection in the water, the dark patches of sea are enlivened with slender, horizontal strokes of the dark cloud mixture, painted with the tip of a round brush. When you paint a moonlit seascape—or a moonlit landscape for that matter—keep several "lessons" in mind. First, remember that a moonlit sky is lighter than the dark shapes of the land below. Second, the colors, lights, and shadows of the sea reflect the sky, just as they do in daylight. Finally, *don't* overdo the moonlight on the clouds and water, scattering touches of white all over the picture; concentrate these light touches at the focal point of your composition.

Step 1. The shapes of the rocky coast are drawn in pencil on cold pressed watercolor paper, which is chosen for this painting because it will be done entirely in thin, fluid washes, very much like watercolor. Before the painting is begun, the pencil lines are lightened with a kneaded rubber eraser. To avoid abrading the surface of the paper, the eraser is pressed against the pencil lines and lifted away, rather than scrubbed back-and-forth. Thus, the lines are almost invisible in Step 2.

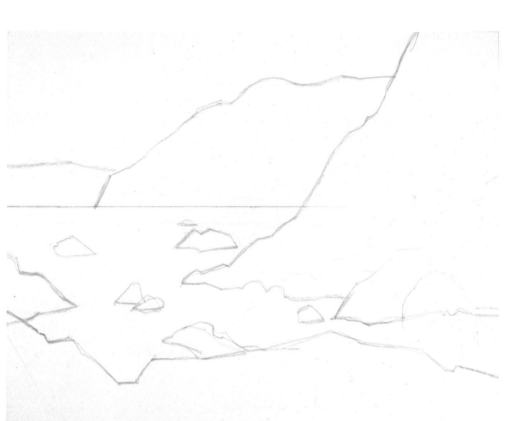

Step 2. The shadow planes and the cracks between the rocks are painted with a flat softhair brush carrying a fluid mixture of ultramarine blue, naphthol crimson, yellow ochre, and water. More water is added for the paler strokes. The color is transparent. Before painting the blurred top of the two distant cliffs, the sky is painted with a very pale wash of the same mixture used to paint the rocks in the foreground; while this wash is still moist and slightly shiny, the tops of the cliffs are painted with darker strokes that blur into the wetness. The lights of the foreground rocks and sea remain bare paper.

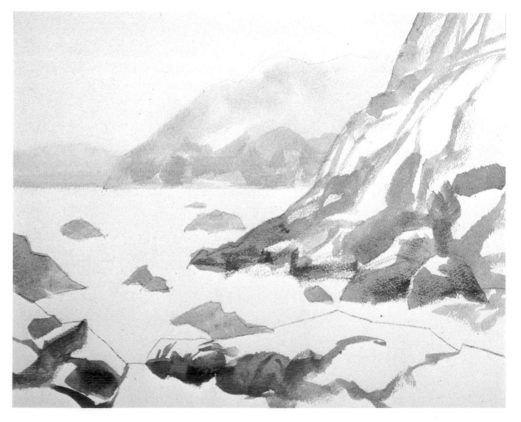

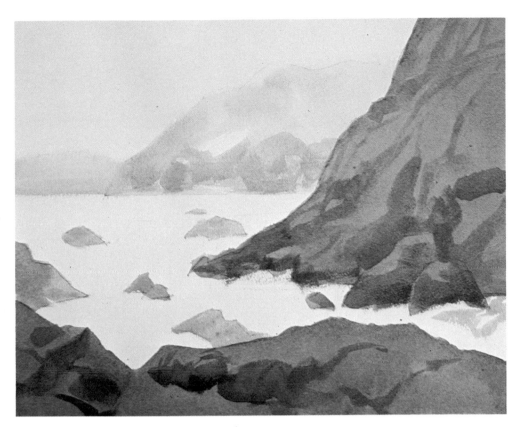

Step 3. When the shadow strokes are dry, a flat softhair brush covers the foreground rocks with a transparent wash of ultramarine blue, naphthol crimson, burnt sienna, and water. Now these shapes are distinctly darker—and therefore nearer—than the paler shapes in the distance.

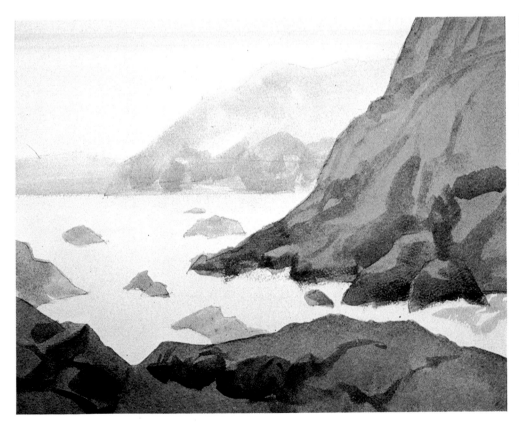

Step 4. Now a pale wash of phthalocyanine blue, naphthol crimson, yellow ochre, and lots of water is carried over the entire picture—the first step in creating a veil of fog that will gradually become denser in succeeding steps. Now the picture has a slightly cooler, more unified tone.

Step 5. When Step 4 is dry, a touch of white is added to the mixture of phthalocyanine blue, naphthol crimson, and yellow ochre. Diluted with a great deal of water, this misty tone is washed over the entire surface of the painting with a large, flat softhair brush. Now the fog is beginning to thicken as a slight veil appears over the rocks, both near and far.

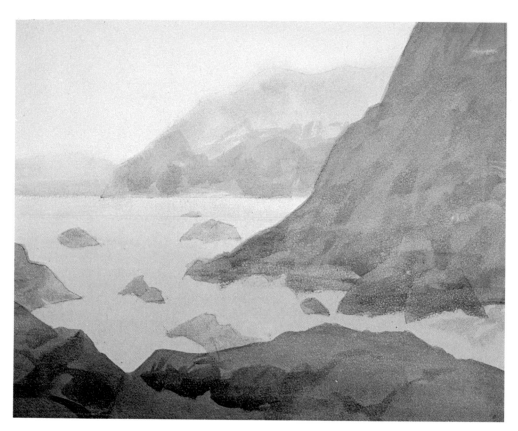

Step 6. When Step 5 is dry, another wash of this misty mixture is brushed over the rocks in the immediate foreground. Then a little more white is added—though not enough to make the mixture opaque—and this misty tone is carried over the sea, the cliff to the right, the distant cliffs, and the sky. Now each successive rock formation seems farther away. A little more white is added to the mixture, and the tip of a round brush adds lines of foam around the rocks.

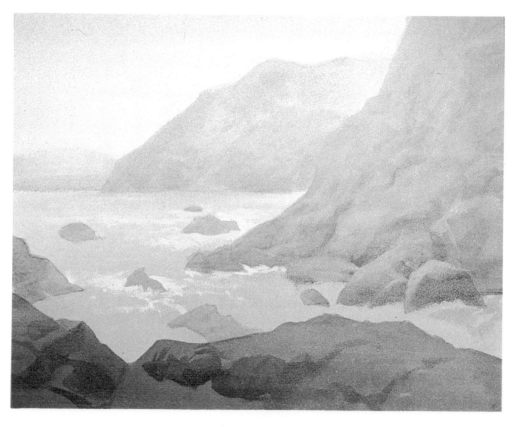

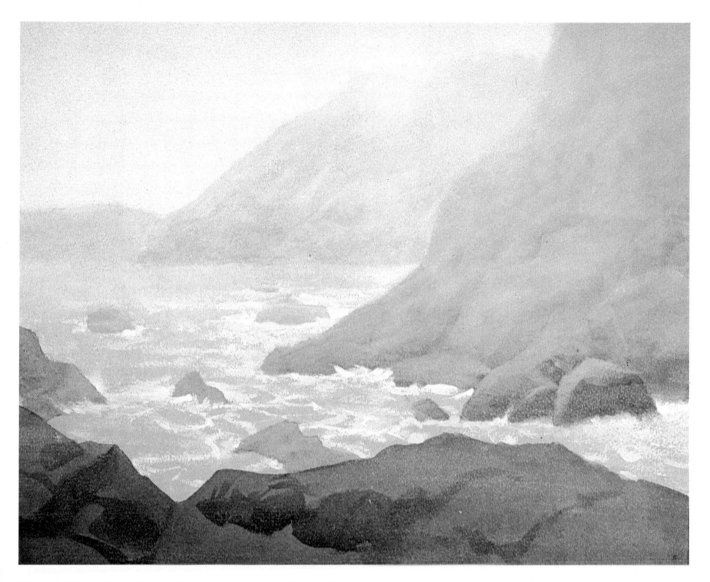

Step 7. When the surface is dry once more, another touch of white is added to the foggy mixture. This semi-opaque tone is brushed over the upper half of the picture and scumbled over the edges of the cliffs to blur their outlines. A round brush draws more lines of foam along the bases of the cliffs, around the rocks, and in the churning water. The completed painting is a dramatic example of the way acrylic color can be used in varying degrees of transparency and opacity to create atmospheric effects. Starting with transparent color, the painting is completed with veils of semi-transparent color, each a little more misty than the preceding veil. The whole trick is to proceed in very gradual stages, always adding a little *less* white than you think you need—so you don't risk covering all the careful work underneath.

Step 1. A sturdy sheet of watercolor board—cold pressed watercolor paper mounted on stiff cardboard by the manufacturer—is brushed with a thin coat of acrylic gesso. The gesso is diluted with water to a consistency of thin cream so that the white paint settles evenly over the paper, showing no brushstrokes. The texture of the watercolor paper is unchanged, but now the surface is slightly tougher and less absorbent than the bare watercolor paper. The gesso coating provides a particularly receptive surface for the opaque technique. Then the shapes of the rocks, the distant sea, and the coastline are drawn in pencil on the gesso surface.

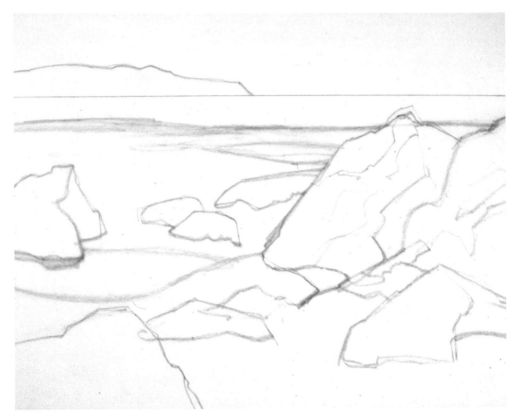

Step 2. A kneaded rubber eraser moves over the painting surface, removing all superfluous lines and lightening the few lines that remain. Then a flat nylon brush covers the rocks with transparent strokes of burnt sienna, ultramarine blue, and yellow ochre, diluted with water. On the gesso surface, these strokes stand out clearly instead of melting together, as they'd be inclined to do on bare watercolor paper.

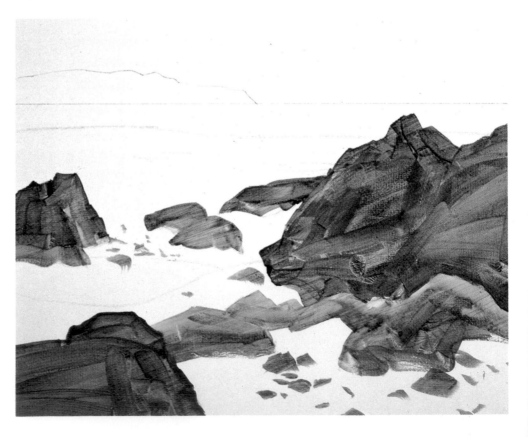

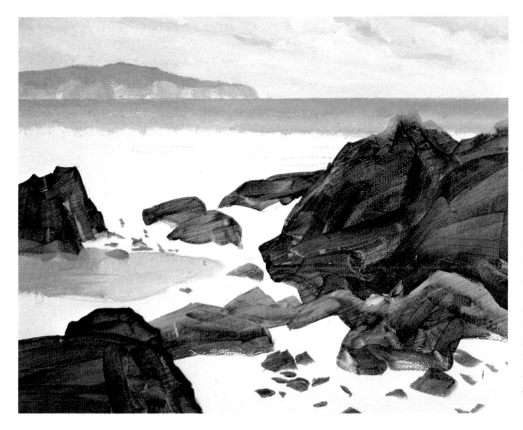

Step 3. The sea and the pool are brushed in with a mixture of phthalocyanine blue, naphthol crimson, yellow ochre, and white—with more white in the lighter passages. The cloudy sky is painted with this same mixture—containing more white in the clouds—since the sea and sky must match. The blues of the sky are painted first; then the clouds are scumbled over and into the wet blues. The distant headland is painted with this mixture, but in different proportions: more blue and less white on the dark top; more crimson, yellow ochre, and white on the paler slopes. The rocks are darkened with a transparent wash of ultramarine blue, burnt sienna, and water.

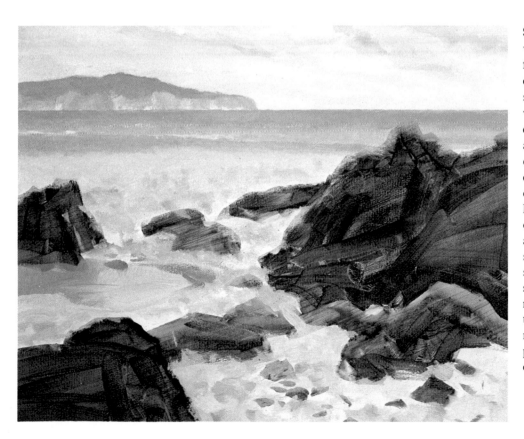

Step 4. The sand is covered with a smooth, opaque, but fairly fluid mixture of phthalocyanine blue, naphthol crimson, yellow ochre, and lots of white. Over this smooth undercoat, a small bristle brush adds individual touches and dabs of this same mixture—containing less white—to indicate pebbles and the irregular texture of the sand. Some of the sea tone is scumbled in at the edge of the beach to suggest the wetness of the sand. You can see that the surrounding colors are beginning to obscure the edges of the rocks, but this will be corrected when the rocks are repainted in thicker, more opaque tones.

Step 5. The lighted planes of the rocks are brushed in with a small bristle bright carrying thick, opaque color. This is a dense mixture of ultramarine blue, burnt sienna, yellow ochre, and white. The paint is the consistency of thick cream, and the brushstrokes are roughened by the texture of the watercolor board. The brush also touches the tops of some of the pebbles scattered between the larger rocks.

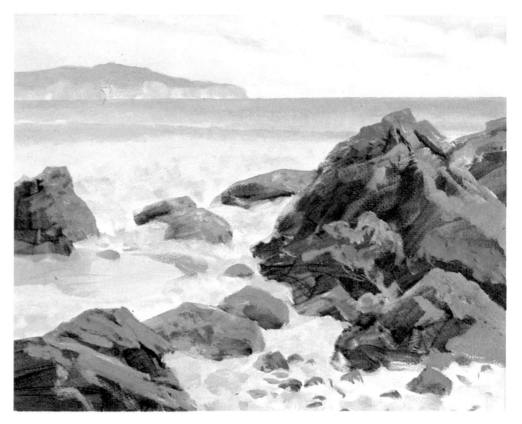

Step 6. The dark sides of the rocks are painted with a flat nylon brush carrying ultramarine blue, cadmium red, yellow ochre, and just a hint of white. Look carefully at the big rock on the right, and you'll see how the shapes of the shadows are painted with great care, slightly overlapping the edges of the lighted planes that were painted in Step 5. Thus, the planes change their shapes. The shadow sides of the foreground rocks aren't completed yet. More white is added to this shadow mixture, and this lighter tone is brushed over the sand to suggest the shadows cast by the big rocks.

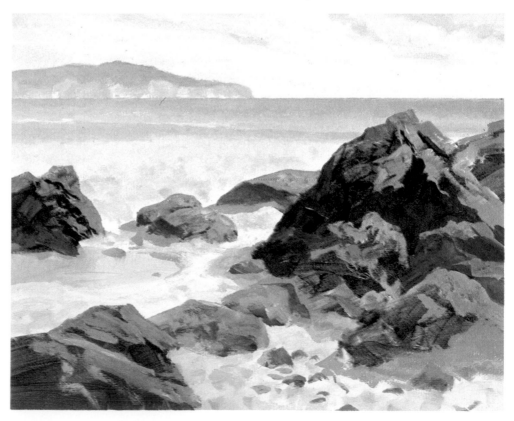

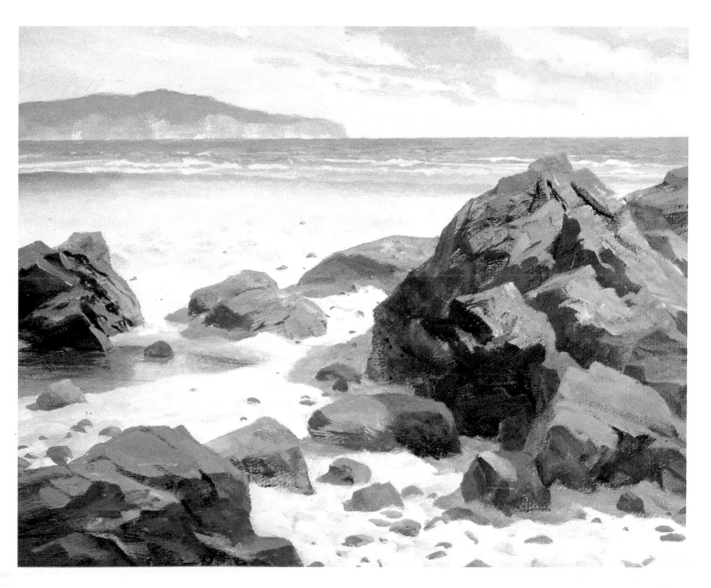

Step 7. The shadow sides of all the rocks are now darkened with a mixture of ultramarine blue, cadmium red, yellow ochre, and a little white. Then a bristle brush picks up more of the original mixture that was used to paint the lighted planes: ultramarine blue, burnt sienna, yellow ochre, and white, diluted with just a little water so that the paint is thick and pasty. Strokes of this mixture define the lighted planes of the rocks more clearly and give them a rougher texture. Some final dark touches are added to the shadow sides of the rocks with ultramarine blue, cadmium red, yellow ochre, and a hint of white. In the process of reinforcing the lights and darks, their shapes have changed to form a more satisfying design; compare the completed rocks in Step 7 with those in Step 6. The tip of a round softhair brush picks up the fluid shadow mixture to add some cracks and details among the big forms of the rocks. This same brush adds a dark reflection in the pool at the left. A bristle brush goes back over the sand with a slightly thicker version of the original mixture: phthalocyanine blue, naphthol crimson, yellow ochre, and lots of white. The sand in the distance is simplified and looks smoother. In the foreground, some of the darker touches and some of the pebbles are eliminated. Then a small bristle brush adds some other pebbles with the same light and shadow mixtures used to paint the rocks. Most of the pebbles are now concentrated in the center foreground—a big, distracting pebble at the lower right has been painted over with sand color. The sky needs more blue to harmonize with the water; a big patch of phthalocyanine blue, naphthol crimson, yellow ochre, and white is scumbled in to create a break in the clouds. The tip of a round brush draws wavy lines of white—tinted with some sky color—over the water to suggest the foamy tops of waves rolling toward shore.

Step 1. The curving, rhythmic shapes of dunes are extremely subtle, and they can be difficult to draw. To get the shapes exactly right, it's a good idea to draw them first on a separate sheet of paper that's tough enough to withstand repeated erasures. You can then blacken the back of the sheet with charcoal or soft pencil, place the sheet on top of the painting surface, and transfer the drawing by going over the lines with a hard pencil. This is obviously a variation of the tracing paper method you read about earlier. In this preliminary drawing, you can see that the lines have been drawn and redrawn to refine the shapes.

Step 2. When the drawing is transferred to the watercolor paper, the heavy, multiple lines of Step 1 become precise single lines. The sky is first covered with a fluid, semiopaque wash of phthalocyanine blue, yellow ochre, and white. Ultramarine blue and white are brushed across the top and blended into the wet undertone. Now the sky is darker and cooler at the top, paler and warmer at the horizon. When the sky dries, a single, dark stroke of the sky tone—now combining ultramarine blue, phthalocyanine blue, yellow ochre, and a little white—is carried across the sea. While this stroke is still wet, the lower edge is softened with a stroke of clear water.

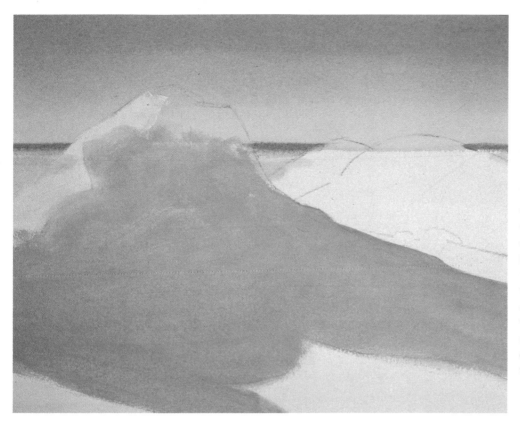

Step 3. Just beneath the dark line of the water, the small, triangular forms of the distant beach are scumbled with ultramarine blue, naphthol crimson, cadmium yellow, and white. The paint is thin and just slightly opaque. More white is added to this mixture, which is painted down the sunlit edge of the big dune. Before this tone is completely dry, the shadow of the dune is painted with darker strokes of the same mixture containing less white. The shadow tone gradually changes from warm to cool. The warm strokes toward the top contain more crimson and yellow. The darker strokes toward the bottom contain more blue.

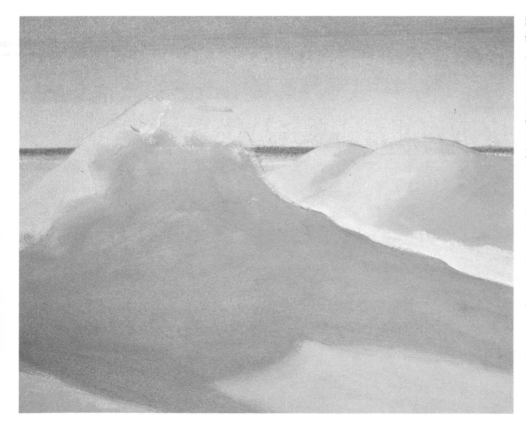

Step 4. The sunlit sides of the two smaller dunes, as well as the sunlit patches on the flat sand, are painted with the same mixture used for the lighted side of the big dune in Step 3: ultramarine blue, naphthol crimson, cadmium yellow, and a lot of white. While the sunlit planes of the small dunes are still damp, the shadow sides are scumbled with a darker version of this same mixture—containing less white—so that the light and shadow blend softly together. This blending gives a rounded shape to the dunes. The texture of the watercolor paper softens the brushstrokes and makes the blending easier.

Step 5. Over the blue sky, a flat nylon brush scumbles some clouds with diagonal strokes. These clouds are the same mixture used for the lighted sides of the dunes: ultramarine blue, naphthol crimson, yellow ochre, white, and enough water to make the paint flow smoothly. Then a small, flat bristle brush adds the first dark vegetation to the top of the dune with drybrush strokes. This is a thick mixture of ultramarine blue, burnt sienna, yellow ochre, a little white—and not much water. The drybrush strokes are particularly ragged because the brush is held almost parallel to the paper. The flat side of the brush does most of the work.

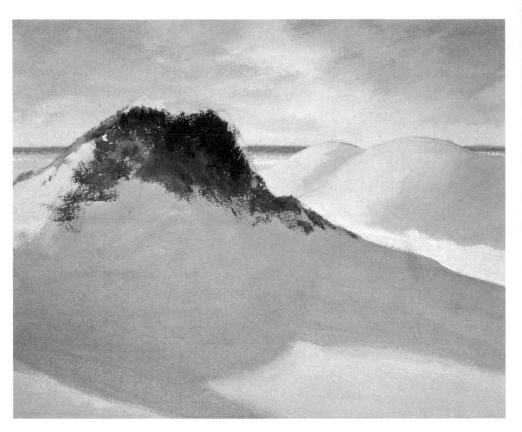

Step 6. The distant grass is drybrushed with the tip of a small bristle brush carrying the same mixture—plus more white—that was introduced in Step 5. The brush is pulled upward to make a ragged, vertical stroke that suggests individual blades and stalks. The tip of a small, round soft-hair brush adds a little water to the dark mixture, which now becomes more fluid and more suitable for precise brushwork. This brush carries some slender lines of grass down the side of the big dune and brings some individual blades from the top of the dune into the sky. The flat side of the bristle brush adds more smudges to the side of the big dune.

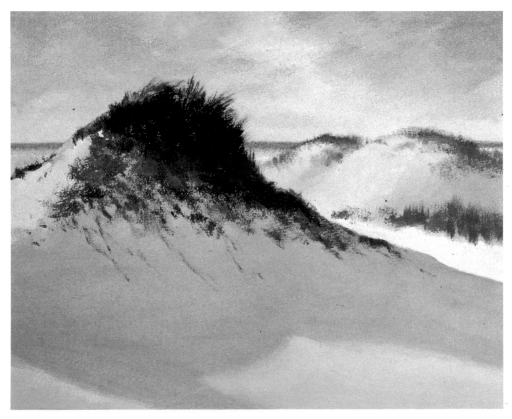

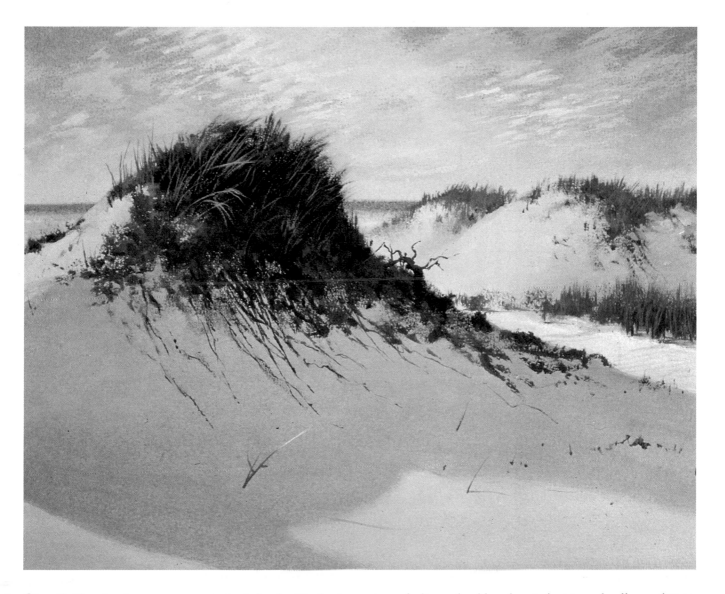

Step 7. The clouds are more precisely defined with short, parallel, diagonal strokes of white tinted with the slightest touch of phthalocyanine blue, naphthol crimson, and cadmium yellow. The brush skims lightly over the paper so that the texture of the painting surface roughens the stroke. The sharp point of a small softhair brush adds more vertical drybrush strokes to thicken the growth on the distant dunes: a mixture of ultramarine blue, cadmium yellow, cadmium red, and white. More water is added to this mixture for precise brushwork. Then the point of the brush adds pale blades of grass with straight and curving strokes against the darkness of the big dune at the left. Not *too* many strokes are added—just enough to suggest more detail than you actually see. The small brush picks up the original dark mixture of ultramarine blue, burnt sienna, and yellow ochre to draw more lines of vegetation that wander down the side of the dune. The bit of driftwood on the right side of the dune is painted with that brush too. The tip of the brush adds a few dark blades to the immediate foreground. The blade just left of center catches a glint of light: it's the same mixture used for the lighted sides of the dunes. Finally, a transparent wash of yellow ochre diluted with a lot of water is carried over the entire sand area, adding a hint of sunny warmth. As you look back at the various steps in this demonstration, you'll notice that the picture is painted mainly with semiopaque color, containing just a little white and enough water to make the paint flow smoothly.

Step 1. The sea invades a shallow stretch of coastline to form a complex pattern of water and "islands" of marsh grass. The shapes of the water and the grass form an interlocking design that must be carefully drawn to keep the shapes varied and interesting. The painting surface is a sheet of illustration board on which the shapes of the composition are drawn in pencil. Then most of the pencil lines are erased with kneaded rubber, leaving just a few faint lines that you see in Step 2.

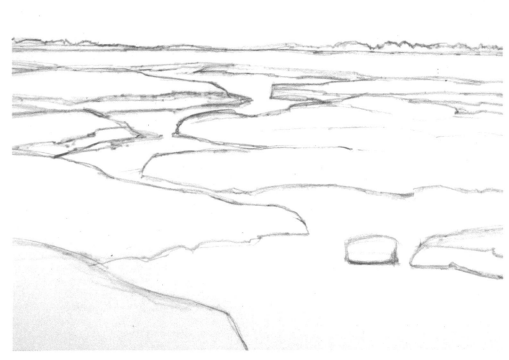

Step 2. A stiff bristle bright picks up ultramarine blue, yellow ochre, and a good deal of water. The brush is damp, rather than wet, and the bristles apply this transparent mixture with an up-and-down scribbling motion that retains the marks of the bristles. All the grassy shapes are indicated with these loose, scrubby strokes. As the brush moves back toward the horizon, more water is added. A flat softhair brush covers the sky with clear water. Then a round softhair brush mixes a wash of ultramarine blue, naphthol crimson, and yellow ochre, diluted only with water, and pulls this tone across the wet sky with long, horizontal strokes.

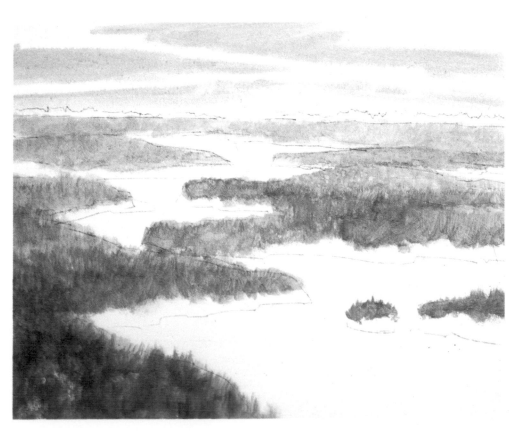

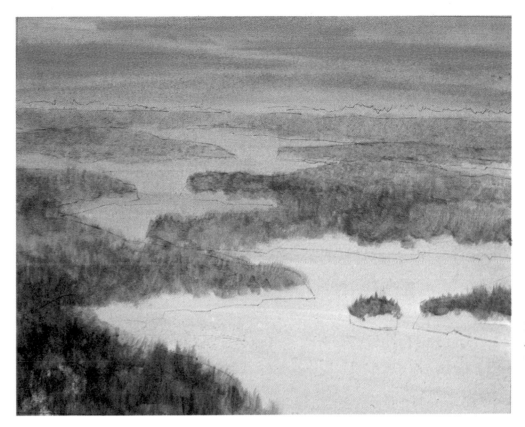

Step 3. The sky is allowed to dry. Then a cool tone is brushed over the entire painting surface with a large, flat softhair brush. This wash is a mixture of ultramarine blue, burnt sienna, and yellow ochre, plus enough water to produce a watercolor consistency. The brush starts at the top of the picture and works down to the bottom with a series of horizontal strokes, each slightly overlapping the stroke above it; the marks of the brush fuse into a continuous tone. More water is added to the strokes as the brush approaches the bottom of the picture. Thus, you have a *graded wash* that moves from dark to light.

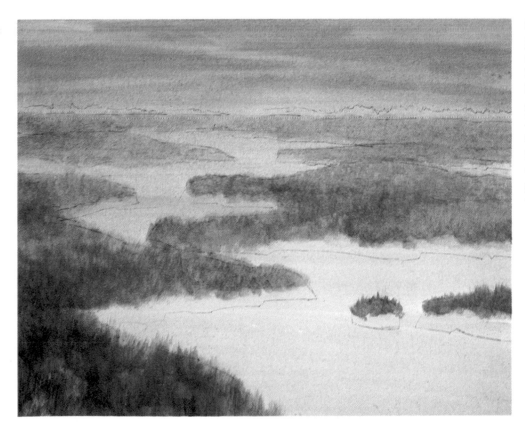

Step 4. The overall tone applied in Step 3 is allowed to dry. Then a large, flat softhair brush picks up a wash of burnt sienna, yellow ochre, and water. The brush is held like a pencil—almost perpendicular to the painting surface—and scribbled up-and-down over the "islands" of grass, which now take on a warm, rich tone.

Step 5. A small bristle brush paints the dark silhouette of the trees and dunes along the horizon. This is the first semi-opaque color in the painting: ultramarine blue, naphthol crimson, yellow ochre, and white, diluted with water to a milky consistency. The dark tones beneath the "islands" of grass—and the dark reflections in the water—are painted with ultramarine blue, burnt sienna, yellow ochre, and a little white to add opacity. To paint the rough lower edges of the reflections, the brush is merely dampened with color and scrubbed up-and-down to make the reflection look slightly fuzzy.

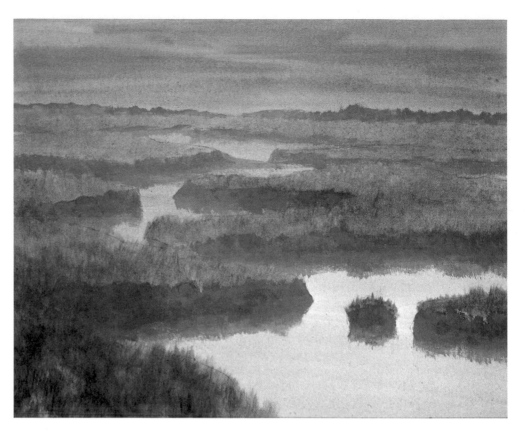

Step 6. Now the lighted tops of the grass are enriched with thicker, more opaque color. A bristle bright carries a creamy mixture of cadmium red, yellow ochre, ultramarine blue, and white. The brush is pressed lightly against the painting surface and stroked upward to suggest the rough marsh grass. The opaque color is applied unevenly, leaving some gaps where the undertone shows through. Notice the effect of aerial perspective: the distant grass is paler and cooler, containing more blue and white. There's also less contrast between light and shadow in the distance.

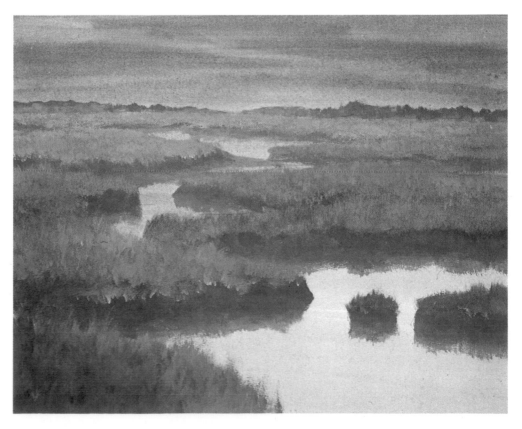

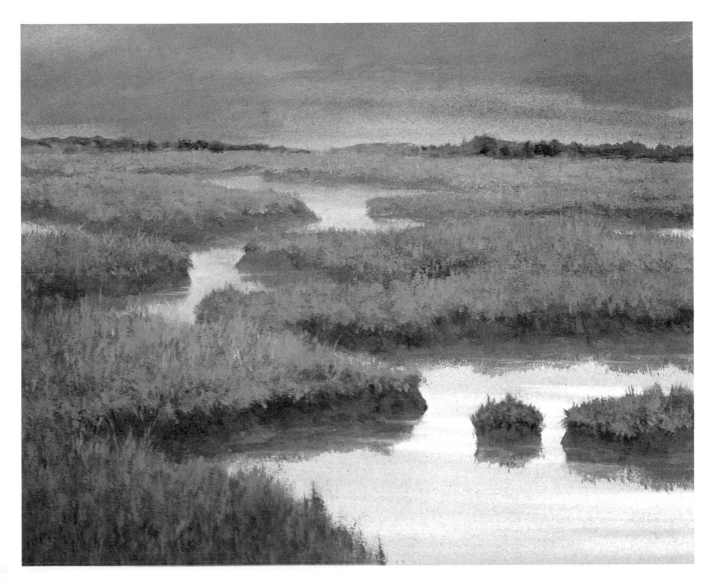

Step 7. This particular kind of illustration board is slightly rough, something like watercolor paper, and this surface becomes useful in suggesting the texture of the marsh grass in the final stage of the painting. The grass is completed with a thick mixture of cadmium red, yellow ochre, ultramarine blue, and white—the same colors used in Step 6, but containing less water, so the paint is quite dense. A bristle brush picks up this thick color and drybrushes the grassy tone over the "islands" in the marsh. The texture of the board roughens and breaks up the strokes, allowing dark flecks of the undertone to show through. The resulting color of the marsh grass is now a combination of all the different tones that have been applied at various stages in the painting, each color influencing the color applied on top. In this final stage, the bristle brush never covers the grass with an even tone, but moves lightly over the textured surface to deposit the thick color in ragged strokes. (It often helps to use the flat side of the brush, rather than the tip.) Then a round softhair brush picks up more of the grassy color to add slender, vertical strokes to suggest individual blades here and there. The horizontal streaks of light on the water are executed in an offbeat way. On this pale area, the color is so thin that it can be removed with the sharp edge of a hard rubber eraser. A ruler lies flat on the painting surface and guides the back-and-forth movement of the eraser as it removes streaks of color and reveals the bare board beneath. These lines are carried into the dark reflections with the tip of a brush that carries pure white diluted with a lot of water. Some darks are added to the horizon with touches of ultramarine blue and burnt sienna. Finally, the sky is simplified and darkened with a semi-opaque scumble of ultramarine blue, naphthol crimson, yellow ochre, and white.

Step 1. The headland is drawn like so many jagged building blocks with clearly defined vertical planes of light and shadow. The drawing is first made on a sheet of tracing paper and then transferred to a sheet of illustration board by the method you've already read about earlier. In the process of transferring the drawing—as you see in Step 2 below—many of the lines have been left out. However, the tracing paper is saved for reference. As the painting is executed, the original drawing will be consulted to determine the locations of the planes.

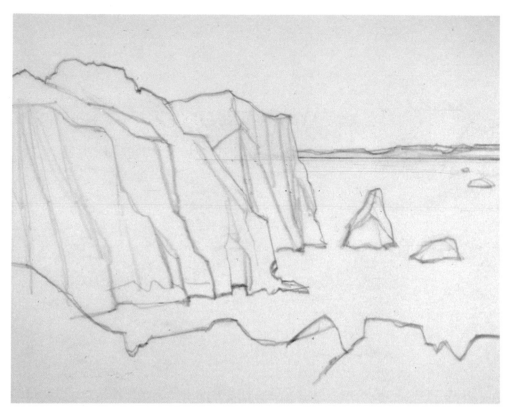

Step 2. The sea is painted with horizontal strokes of phthalocyanine blue, burnt sienna, yellow ochre, and white. As the strokes approach the horizon, more white is added. The shadowy undersides of the clouds are scumbled with the same mixture containing a bit more burnt sienna. The sunlit edges of the clouds are painted with yellow ochre and white scumbled into the shadows for soft transitions. The blue sky, breaking through the clouds at the top, is ultramarine blue, phthalocyanine blue, a little yellow ochre, and white. The blue patches in the middle of the sky are phthalocyanine blue, yellow ochre, and white. All these scumbling strokes are the work of flat bristle brushes.

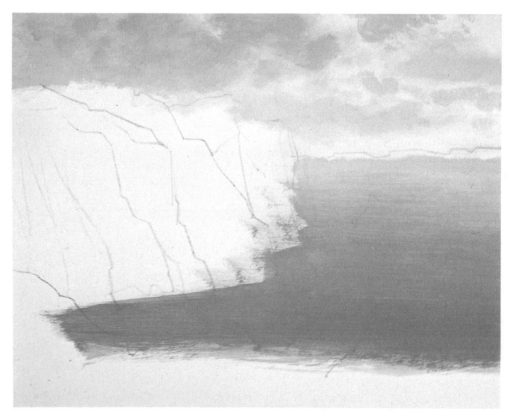

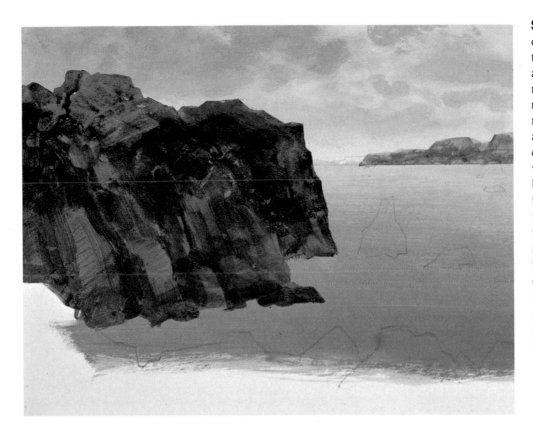

Step 3. The original drawing on tracing paper is laid over the painting surface once again, and the lines of the rocks are retraced. Then naphthol crimson, ultramarine blue, Hooker's green, and water are mixed to the consistency of transparent watercolor. A flat bristle brush scrubs this tone over the big headland and the distant shore. As you can see, the strokes vary in density. Some are much darker, containing less water. These darker tones become the shadow planes. The bristles of the brush leave scratchy marks in the wash; the marks will disappear in later stages.

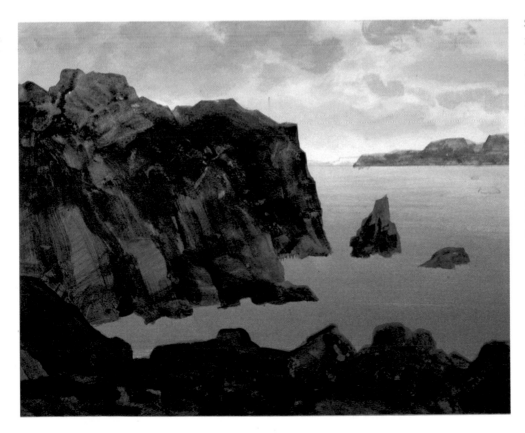

Step 4. This same mixture of naphthol crimson, ultramarine blue, Hooker's green, and water is brushed over the smaller rocks that stand offshore and the dark rock formation in the immediate foreground. The strokes of the foreground rocks contain less water, but they're still transparent enough to permit the light tone of the illustration board to shine through in some places.

Step 5. The dark, looming headland becomes darker still as a flat nylon brush subdues the color with a transparent wash of Hooker's green, burnt sienna, and water. A round softhair brush draws the foam at the foot of the headland with thin, horizontal strokes of white diluted with water to the consistency of thin cream and delicately tinted with phthalocyanine blue, yellow ochre, and naphthol crimson. The foreground rocks are lightened with an opaque mixture of ultramarine blue, burnt sienna, yellow ochre, and white. Now the dark, ominous form of the headland clearly dominates the picture.

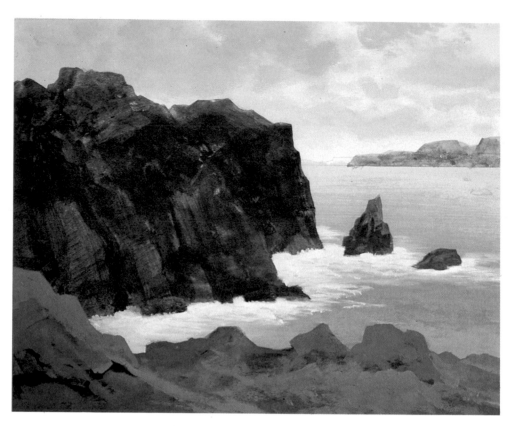

Step 6. The foreground rocks in Step 5 seem to obstruct the viewer's eye, which needs a "path" to enter the picture. The water tone—an opaque mixture of phthalocyanine blue, burnt sienna, yellow ochre, and white—blocks out some of the rocks in the lower right, so the viewer's eye can enter the picture more easily. Then a piece of white chalk is sharpened to redraw the foreground rocks in crisp lines applied directly over the dried color. As you've discovered by now, it's simple to change your mind and make corrections with acrylic paint, since it dries so rapidly and covers the underlying color so easily.

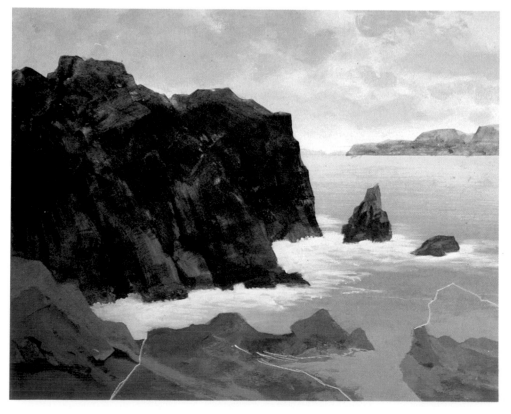

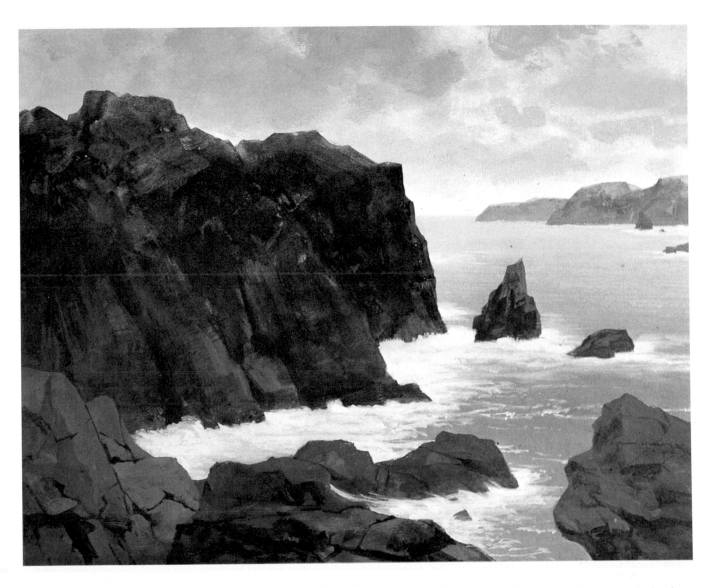

Step 7. The foreground rocks are repainted with thick, opaque mixtures of ultramarine blue, burnt sienna, yellow ochre, and white. The lighted planes of the foreground rocks contain more ultramarine blue and white, while the shadow planes contain more burnt sienna and less white. To draw the cracks and the crisp shadow lines on the foreground rocks, the tip of a round softhair brush adds thin strokes of burnt sienna and ultramarine blue, which make a rich dark. More dark notes, for additional crevices, are added to the big headland with this same mixture. The distant shoreline on the right is now divided into two separate headlands with strokes of ultramarine blue, naphthol crimson, yellow ochre, and white—obviously containing more white along the sunlit tops. The foam patterns along the near shoreline are completed with small strokes of white faintly tinted with the same mixture that's used on the distant shore. The strokes follow the movement of the foam as it moves up over the rocks in the center foreground, runs back down, and trails off into the water. A few more lines of foam are added to the edges of the distant rocks and shore.

Step 1. When the tide goes out, pools of salt water are often left in the low points of the beach. These pools frequently combine with rock formations to make an interesting coastal landscape. To take advantage of the texture of cold pressed watercolor paper, this demonstration is painted on a sheet of watercolor board. The drawing is made on tracing paper and then transferred to the surface of the board.

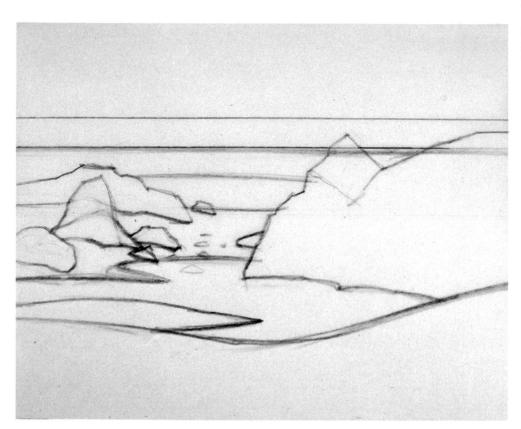

Step 2. The sky is painted with ultramarine blue, phthalocyanine blue, yellow ochre, and white, applied with a flat nylon brush. The brushstrokes at the top contain more ultramarine blue and less white. The warmer, paler tone above the horizon contains more yellow ochre and white. The narrow strip of sea is painted with ultramarine blue, yellow ochre, and white, applied in horizontal strokes; the bristle brush skims lightly over the painting surface, leaving some streaks of bare paper to suggest foam. Ultramarine blue, burnt sienna, and yellow ochre are thinned only with water to produce a transparent wash that's brushed over the tidepools on the beach.

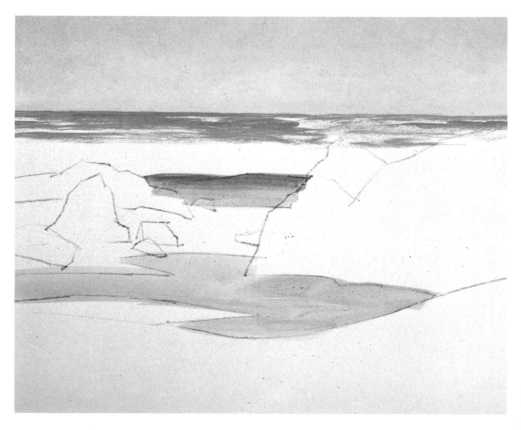

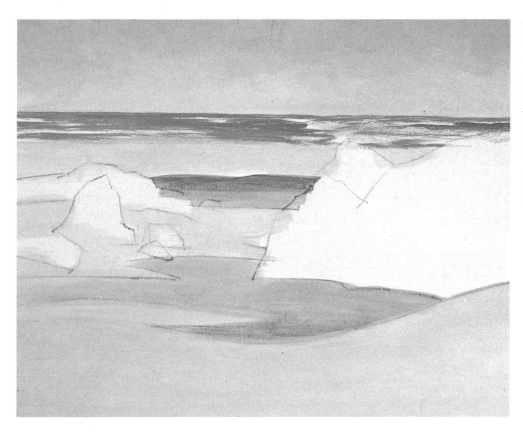

Step 3. Naphthol crimson, ultramarine blue, yellow ochre, and white are diluted with plenty of water to produce a thin, fluid tone that's just slightly opaque. This tone is brushed over the sand and also overlaps the bigger tidepool in the foreground. Although this color runs over the pencil lines, the mixture is thin enough to reveal them.

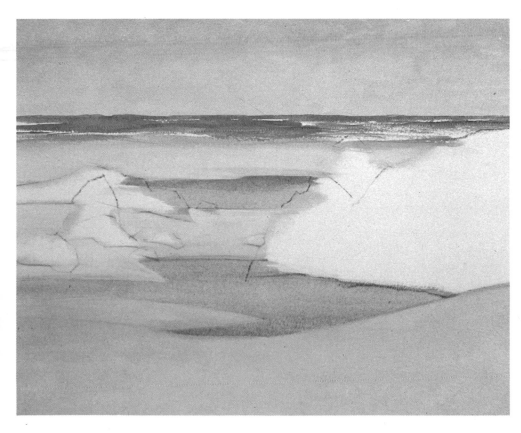

Step 4. The sand in Step 3 is too pale and warm. When the tone is dry, a flat softhair brush mixes another semi-transparent wash of ultramarine blue, burnt sienna, yellow ochre, and a whisper of white. But the wash contains a bit more blue and is brushed over the entire beach, including both tidepools. Now the sand has a cooler, more subdued tone.

Step 5. The rocks are textured with thick, pasty color, undiluted with water or medium. The sunlit tops of the rocks are white tinted with naphthol crimson, ultramarine blue, and yellow ochre. The shadow planes are ultramarine blue, burnt sienna, yellow ochre, and white in varying proportions: some strokes contain more burnt sienna, while others contain more ultramarine blue or yellow ochre. But, at this stage, texture is more important than color. The rough, thick strokes of the bristle brush leave a craggy, impasto surface.

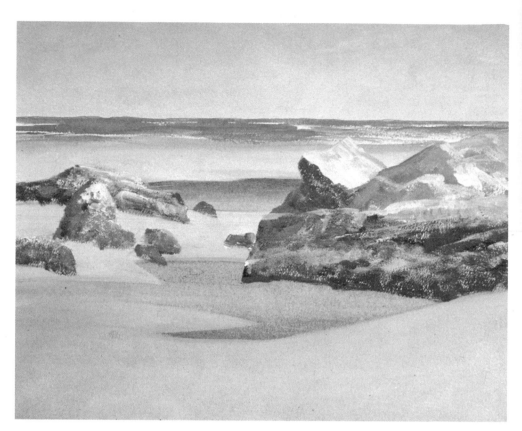

Step 6. The rough texture of the rocks is allowed to dry thoroughly. Then the rocks are glazed with a transparent mixture of ultramarine blue, burnt sienna, yellow ochre, water, and gloss medium. This fluid mixture sinks into the rough, impasto brush marks of Step 5 to produce a rocky texture. Less water is added to this glaze for the shadow planes of the rocks. This tone is carried downward into the pool beneath the big rock, where horizontal strokes render the reflection. When the reflection is dry, both tidepools are darkened with a transparent mixture that's mainly ultramarine blue and water, with a little burnt sienna and yellow ochre.

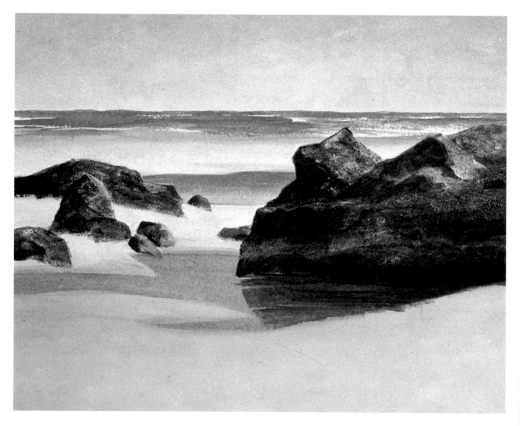

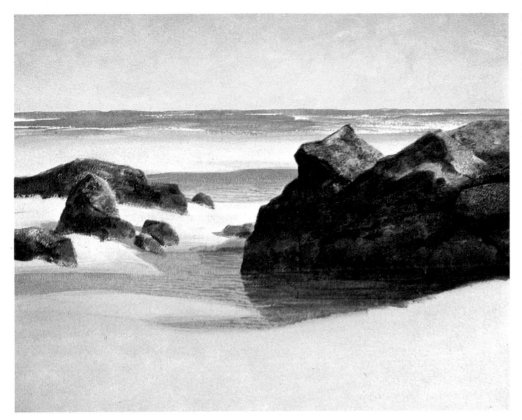

Step 7. The shadow sides of the rocks are darkened with drybrush strokes of the same mixture that was used to glaze the rocks in Step 6: ultramarine blue, burnt sienna, yellow ochre, water, and gloss medium. (The gloss medium thickens the glaze slightly and adds luminosity.) A pointed softhair brush draws cracks in the rocks with a dark mixture of ultramarine blue and burnt sienna. Some smudges of moss are added to the smaller rocks at the left. These are drybrush strokes of phthalocyanine blue, cadmium yellow, and a little burnt umber. Some sky tone and ripples are added to the tidepools with horizontal strokes of ultramarine blue, yellow ochre, and white.

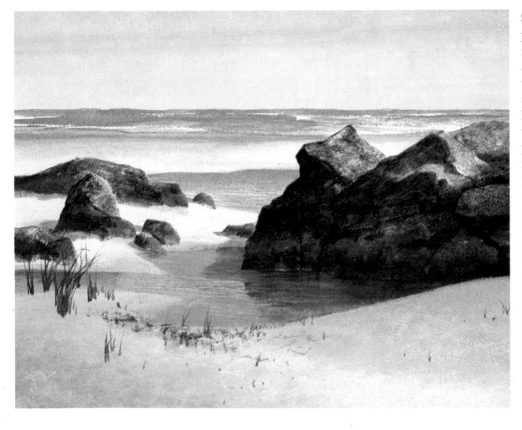

Step 8. More sky tone—phthalocyanine blue, ultramarine blue, yellow ochre, and white—is scumbled into the pools, which reflect the sunny sky overhead. Thin, horizontal lines of this mixture are carried across the pools with the point of a round brush to suggest ripples. A thicker, creamier sand tone is produced by mixing ultramarine blue, naphthol crimson, yellow ochre, and white; this is brushed over the sand in the foreground with short, scrubby strokes that allow the lighter undertone to come through. This brushwork suggests the irregular texture of the sand. The round brush begins to add some blades of beach grass with a fluid mixture of burnt umber, Hooker's green, yellow ochre, and water.

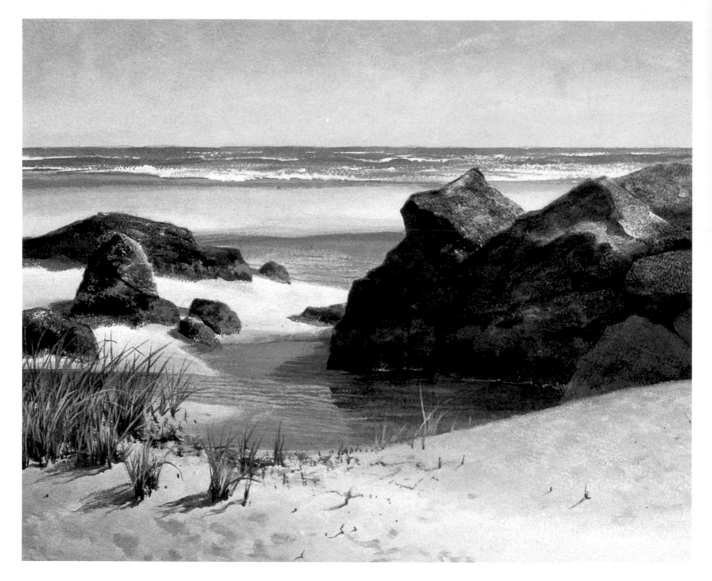

Step 9. The finishing touches are added to the rocks. The flat side of a bristle brush is used to drybrush some burnt sienna and ultramarine blue over the lighted tops of the rocks to produce a speckled texture. This drybrush work is then carried down over the shadowy sides. The moss on the rocks is strengthened with a mixture of phthalocyanine blue and yellow ochre. Additional drybrush strokes of sky tone are carried across the distant pool: a mixture of phthalocyanine blue, yellow ochre, and white. The cluster of beach grass is painted in two operations, very much like the grass on the dune in Demonstration 7. Some dark tones of Hooker's green and burnt umber are drybrushed. When these tones are dry, the point of a round brush adds individual blades with Hooker's green, yellow ochre, burnt sienna, and white. Some blades, caught in sunlight, contain more yellow ochre and white. The curving beach in the immediate foreground is darkened with short, scumbling strokes of ultramarine blue, naphthol crimson, yellow ochre, and white—particularly at the extreme right and left. Some darker smudges of this color suggest footprints in the lower left. The shadows of the beach grass are drawn with thin, wavy strokes of burnt sienna, ultramarine blue, yellow ochre, and white. Finally, the sand is warmed with an almost invisible, transparent glaze of yellow ochre dissolved in pure water.

Center of Interest. Painters love the coastline because it's so easy to find dramatic shapes to paint. Finding the focal point of your picture—a looming cliff, a jagged rock formation, a crashing wave—may not take very long. What usually takes more time and more thought is finding the right vantage point, the right light effect, and the right subsidiary elements.

Vantage Point. You can just set up your painting gear on the beach, look up at the cliff or look out at the waves, and start to paint. But it's usually worthwhile to walk around a bit to find the right vantage point or the right angle from which the subject looks most impressive. If you walk closer to the cliff and then look up at it from the shore below, the horizon seems lower and the cliff seems taller. If you walk farther away, you may have a more panoramic view of cliff, foreground rocks, and distant sea. Either one might make a good picture. Crashing waves are often too far away—and there are often too many of them. They're more dramatic if you get closer. But it's usually hard to get close enough without getting soaked. So the next best solution is to isolate some segment of the biggest wave, plus one or two more waves and perhaps a few rocks, and paint the subject as if you're standing nearby. You'll also find that the picture can change dramatically when you change your eye level. First try sitting at the foot of a rock formation and looking out across the beach. Then climb to the top. See which vantage point you like best.

Lighting. Your vantage point or angle of view will also affect the lighting on your subject. At midday, the sun is directly overhead, and the lighting tends to be uniform everywhere, with very little shadow. But throughout most of the morning and most of the afternoon, the sun is lower in the sky. This means that things like rocks, cliffs, dunes, and waves will have a lighted side and a shadow side. As you walk around your subject, you can decide how much light and how much shadow you want to see. From one angle, you'll see a lot of the sunlit side of the dune, with just a little shadow. Walk halfway around the dune, and you'll see mostly shadow and just a bit of sunlight. The dune (or rock or cliff) may also cast an interesting shadow, which enhances the picture when you stand at a certain spot. Any one of these light effects might make an interesting painting. But try to avoid a 50-50 balance of light and shadow: let the light or the shadow dominate. Especially interesting things happen to the light in early morning and late afternoon, when the sun is really low in the sky. That's when the light is literally *behind* the shapes of rocks, waves, surf, cliffs, headlands, and clouds. Now these shapes are seen as dark silhouettes—which many seascape painters love best.

Secondary Elements. Having found your center of interest, you then have to decide how many other elements you want to include. A crashing wave, throwing up a mass of foam against a rock, may look even more violent with a calm stretch of beach in the foreground and peaceful, horizontal clouds in the distance. The curving shape of a big sand dune may look even more rhythmic if its curves are echoed in a couple of smaller dunes in the distance. And you can call attention to the biggest dune by crowning it with beach grass. That headland may look taller and more jagged if you suggest some low, flat shoreline along the distant horizon. If you're lucky, these secondary elements may be in the picture or nearby. If not, you may have to rely on sketches or on your memory.

Working Indoors. All these suggestions are based on the assumption that you'll be painting outdoors—which isn't always true. Lack of time, changing weather, or just your personal preference may take you indoors more often than outdoors. It's also a lot easier to reorganize nature in the comfort and leisure of your home or studio. If you plan to do most of your painting indoors, the most practical solution is to treat the outdoors simply as a source of material. Go to the coastline with just the equipment you need to make pictorial notes, not to paint a finished picture. Use a sketchpad and a pencil to make quick drawings of ideas for pictures, just blocking in the shapes of waves, clouds, rocks, and dunes. Then turn the page and make more careful drawings of the most important elements in your future picture. Try to record the exact shape of the wave and the pattern of the foam trickling down its face. Or study the precise form of the rocks, with the pattern of light and shadow and texture of the cracks. To record colors, pack just enough painting equipment to make small, simple paintings on scraps of illustration board. Or paint on a pad of thick drawing paper or watercolor paper. An indoor painting does start on location. And a day of outdoor painting can give you enough material for many happy days of painting at home.

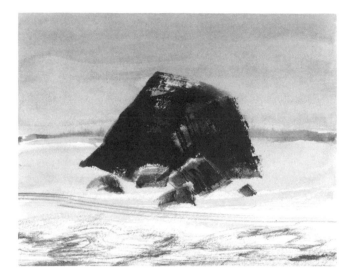

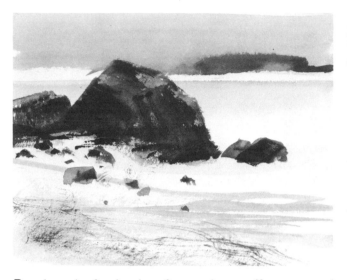

Don't drop the biggest, most important shape into the center of the picture, leaving the same amount of space on either side. And don't draw the horizon across the midpoint of the picture, splitting the composition into two equal halves.

Do place the focal point of your picture off center—and above or below the midpoint of the picture. Push the horizon line below the midpoint or raise it higher, as you see here. When the biggest, most important shape in the picture is off-center—as this rock is—you can then create a more interesting composition by balancing the big shape against some smaller ones.

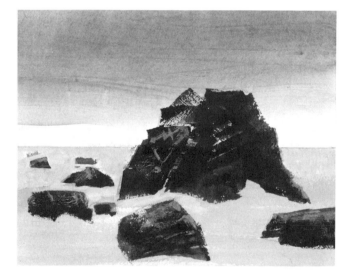

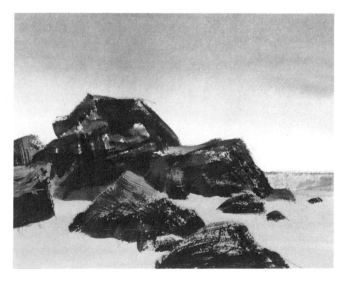

Don't scatter your shapes and make the eye hop around. Even if you find a lot of scattered rocks on the beach, you're under no obligation to copy them exactly.

Do organize the shapes so they interlock, with the smaller shapes leading the eye to the big one that dominates the picture. Now the rocks form a path that leads the eye upward to the big rock that becomes the focal point of the composition.

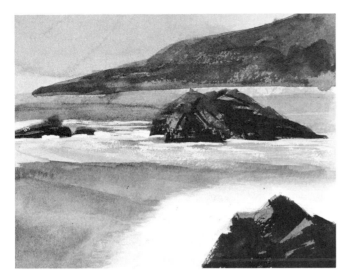

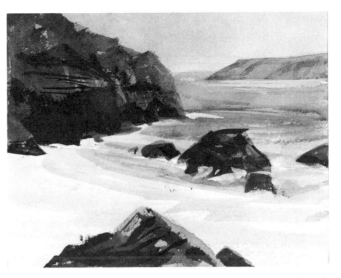

Don't organize the shapes in your composition so that they lead the eye out of the picture. In this coastal scene, the eye enters the picture at the lower edge, follows the line of the beach around to the right, and then keeps going straight out of the picture.

Do plan your composition so that the eye travels to the focal point of the picture. Here, once again, the eye moves along the edge of the beach. But now the curving line of the beach carries the eye to the big headland, which becomes the center of interest.

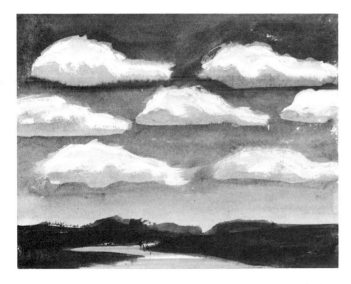

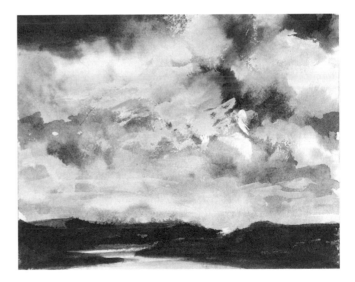

Don't make things the same size and shape, whether they're clouds or rocks or waves. Your composition will become as dull and repetitive as a piece of cheap wallpaper.

Do make your shapes varied and interesting. Merge the small, repetitive shapes of those clouds so that they become a few big, irregular, uneven shapes. Now the clouds themselves are more interesting—and so are the shapes between them, which are just as varied as the clouds themselves.

Rocks in 3/4 Light. The direction of the light is responsible for the distribution of lights and shadows on any three-dimensional form. For this reason, it's important to establish where the light is coming from before you start to paint a subject like this rock formation. Here, the light source—which means the sun—is above the rocks and somewhat to the left. Thus, the rays of the sun strike the tops and the left sides of the rocks, throwing the right sides into shadow. When the light source is above and somewhat to the side, this is called 3/4 light.

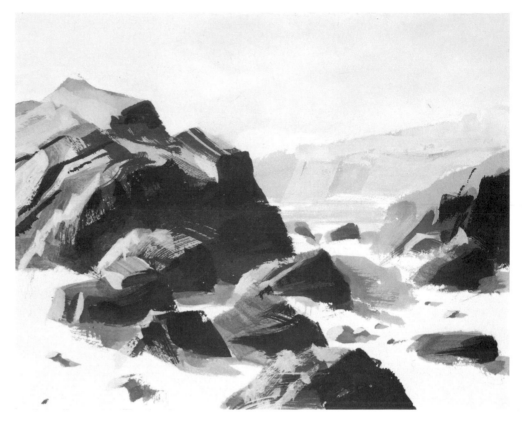

Rocks in Top Light. The sun is directly overhead, with its rays falling vertically on the top planes of the rocks. This plunges the side planes of the rocks into deep shadow. This is how things tend to look at midday, when the sun is high in the sky.

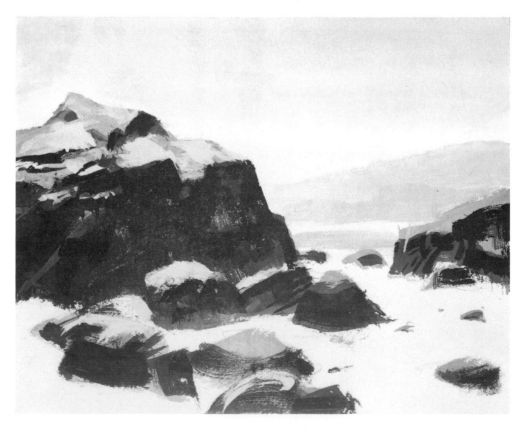

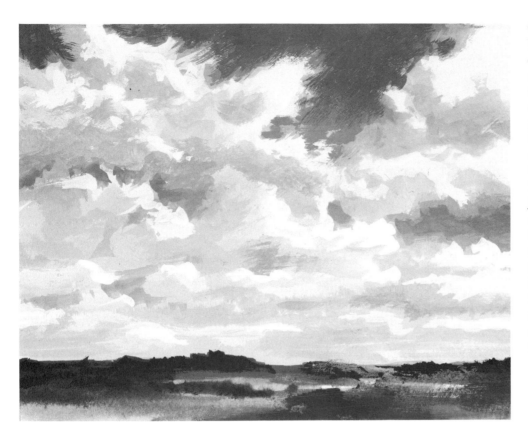

Clouds in 3/4 Light. Don't be deceived by the fact that clouds have softer, more irregular shapes than rocks. Clouds are still solid, three-dimensional forms. If you're going to paint clouds convincingly, you've got to pay attention to the direction of the light, so you can record the light and shadow planes just as you'd paint them on a rock formation. Here, the sun is above the clouds and to the right. Thus, the tops and right sides of the clouds are in bright sunlight, while the bottoms and the left sides are in shadow. Notice how the clouds also cast shadows on the landscape below.

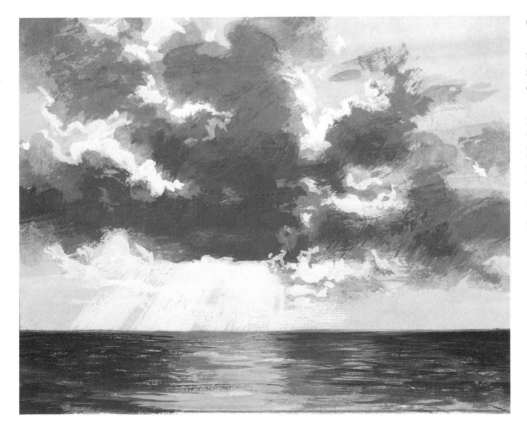

Clouds in Back Light. When clouds cover the sun, the sides facing you are in shadow. The clouds become dark, dramatic silhouettes with sunlit edges. In the early morning and late afternoon, the sun is low in the sky, behind headlands and rock formations, just as it is behind these clouds. Thus, the shapes of the shore are also particularly dramatic when they're backlit.

Rocks. The most effective way to create a sense of deep space in a coastal landscape is to emphasize the "laws" of aerial perspective. According to these "laws," near objects are darkest, show the most detail, and exhibit the strongest contrast between their lights and shadows. Objects in the middle distance are paler, less detailed, and lower in contrast. The most distant objects are the palest and least detailed, exhibiting little or no contrast between lights and shadows. Compare the rocks in the foreground, middleground, and distance to see how this works out in practice.

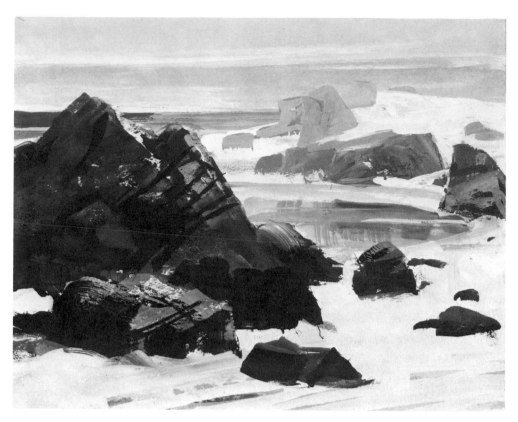

Dunes. The effects of aerial perspective are just as obvious in the dunes and beach grass of this coastal landscape. On the nearest dune in the lower left, the grass is darkest and most detailed. The big dune in the upper left—which represents the middleground—is obviously paler, and it's certainly harder to see the individual blades of beach grass. The most distant dunes are in the upper right: you can barely make out the difference between the lights and shadows; and the beach grass on the tops of the dunes is just a blur. Notice that the distant sea is even paler than the dunes.

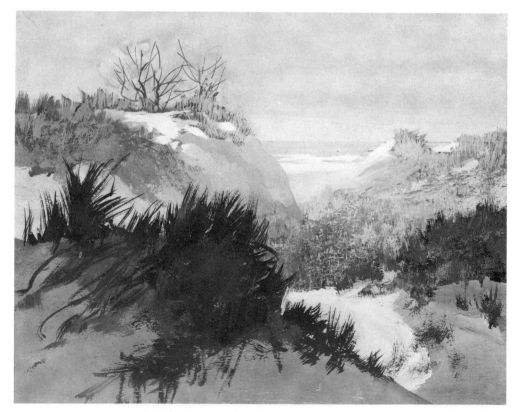

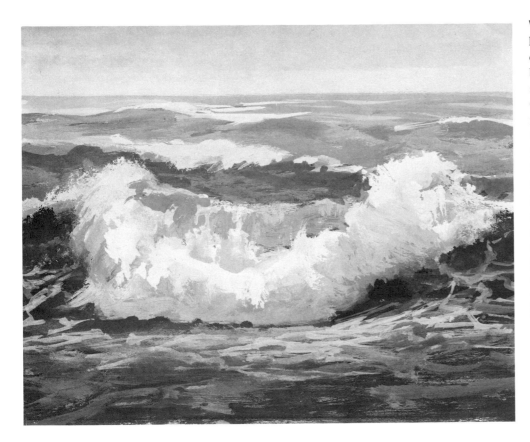

Waves. The nearest wave has strong lights and shadows. You can see a clear break between the sunlit and shadow planes of the foam. Clearly efined trails of foam run down the dark face of the wave to the right and left of the crashing surf. The wave in the middle distance is obviously paler and less detailed: you can no longer see a clear break between the lights and shadows on the foam; nor can you see any foam trickling down the dark face of the wave. The distant waves are paler still, revealing no detail at all.

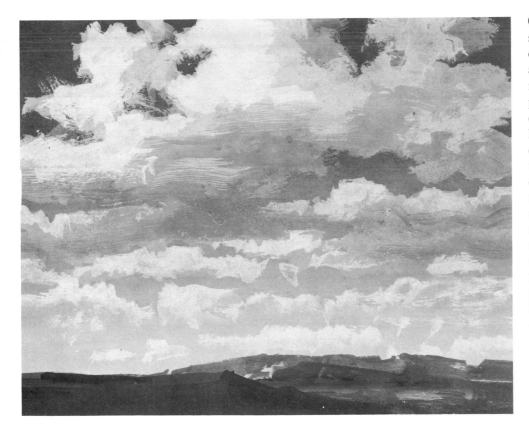

Clouds. Don't neglect perspective when you're painting clouds. The nearest clouds are directly overhead, which means they'll be high in the picture and bigger than more distant clouds. They'll also have stronger lights and shadows, and you'll be able to see the details of the edges more clearly. As the clouds move farther away, they'll be smaller and closer to the horizon. You'll see little or no contrast between their lights and shadows. And you'll paint their edges with less precision. The clouds at the horizon are the most distant and the least distinct.

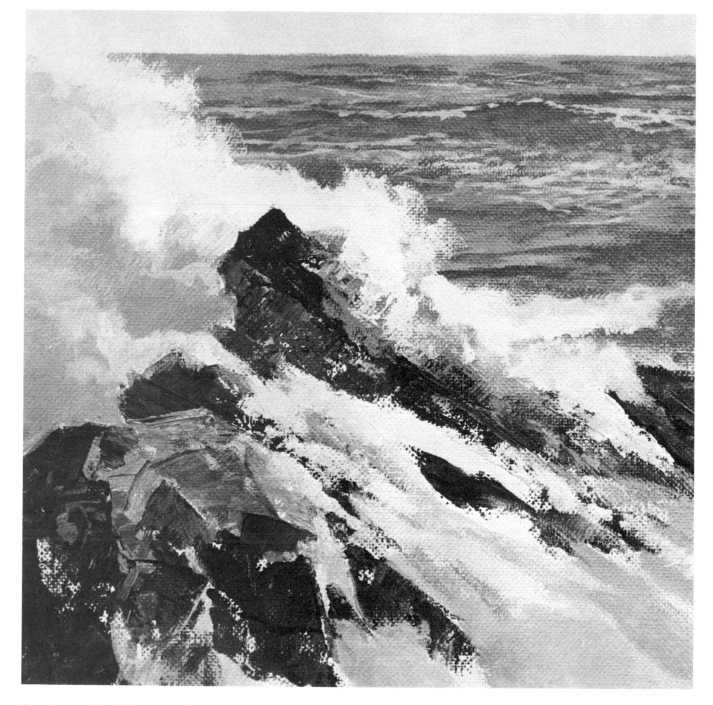

Rocks and Surf. The secret of expressive brushwork is to make the brush follow the movement or the direction of the form you're painting. The rhythmic swell of the distant waves is painted with slender, horizontal, rhythmic strokes of the tip of the brush, which actually moves over the water with a wavelike motion. As the surf explodes against the rocks, the brushwork changes totally. Now the strokes are short, decisive dabs and scrubs; the brush actually pulls the strokes upward and outward, moving as the foam moves. Then, as the foam spills over the rocks, the brush carries the foam across the flat tops of the rock formation with long, diagonal strokes that move from left to right. The rocks are painted with short, squarish, decisive knife strokes that correspond to the light and shadow planes of the form.

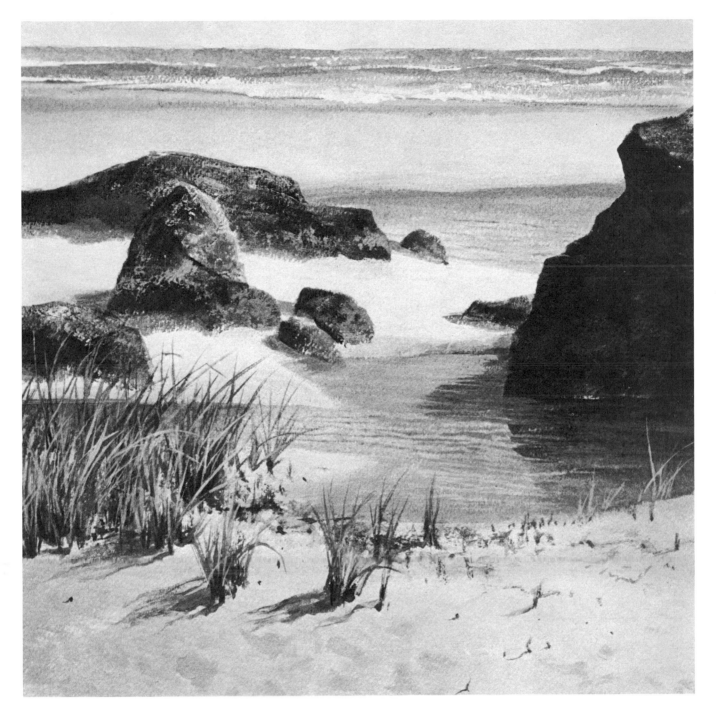

Rocks, Tidepools, and Beach Grass. The varied textures of this subject are reflected in the brushwork. The sand is painted with soft, smooth strokes of fluid color. In contrast, the rough texture of the rocks is rendered with drybrush strokes that emphasize the texture of the paper. The distant waves and the ripples in the tidepools are painted with wavy, rhythmic, horizontal strokes that suggest the movement of the water. The blades of beach grass are painted with slender strokes that start at the base of each blade and then curve upward, following the direction of the grass. The grass casts wavy shadows on the sand; these shadows are painted with wavy strokes.

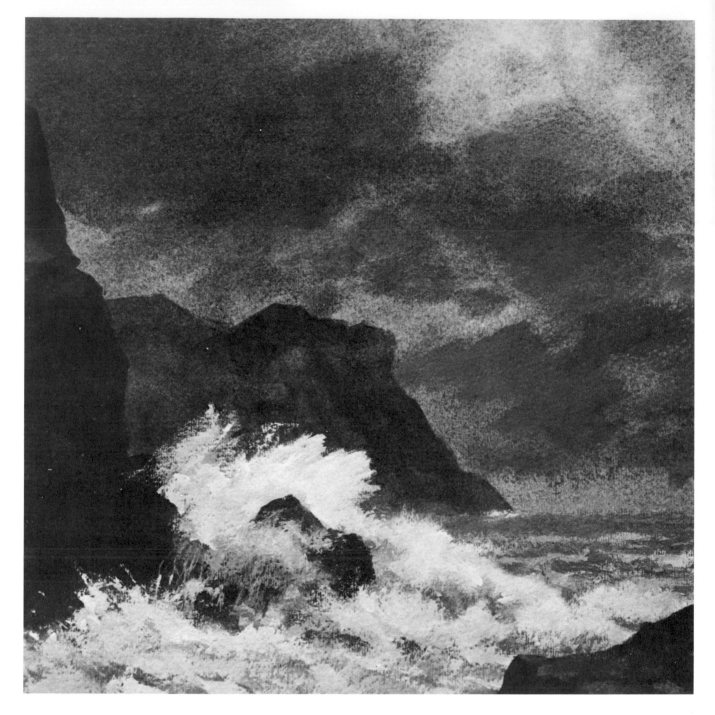

Storm Clouds and Surf. It's obvious that these dark clouds are being blown across the sky from left to right. The big, broad brushstrokes move across the sky in the same direction. Like the flying clouds, the strokes are rapid and turbulent. Where the surf strikes the rocky shore and flies back toward the sea, the strokes pull the paint diagonally upward, from left to right. The surf and the clouds seem to imitate each other's movements—and so does the brush.

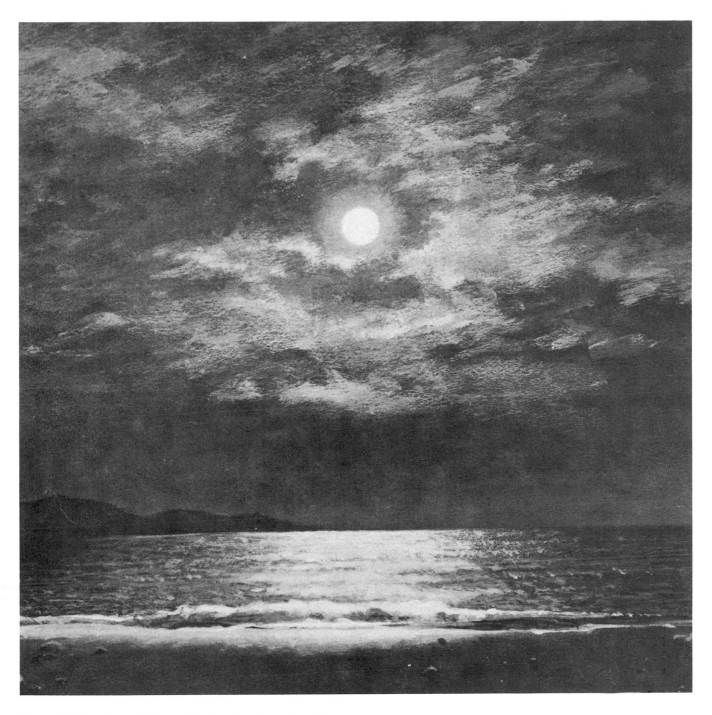

Moonlit Clouds and Sea. Like the clouds on the facing page, these moonlit shapes are obviously moving across the sky from left to right. But this is a serene sky, and the glowing clouds are moving more slowly. Now they're painted with soft scumbles. The brush moves gently back-and-forth over the textured paper, allowing the texture to come through and soften the stroke. The moonlight on the sea is also painted with gentle touches. The brush moves horizontally, depositing row upon row of small strokes. As the brush moves away from the bright reflection, the touches become smaller and farther apart, so the dark sea shows between them. The gentle movement of the clouds and water is expressed by gentle brushwork.

Swells. There are many different kinds of wave forms. Learn to identify them so you know what you're painting. In the open sea, the rhythmic shapes of the ocean are called swells. Their sides tend to be in shadow. Their tops and the troughs between the waves are lighter because they face upward and catch the light of the sky. Notice how these swells are painted with curving, arclike movements of the brush, suggesting the action of the water.

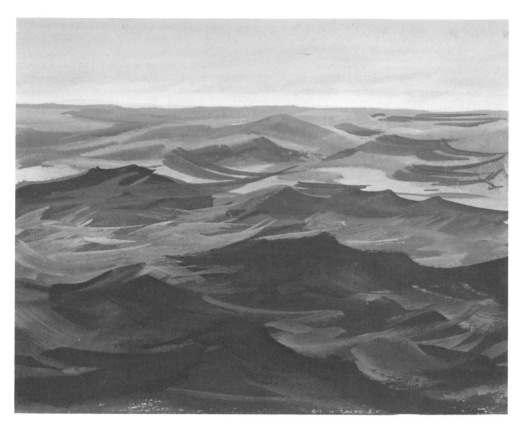

Whitecaps. When you see foam on a wave in the open sea, it's usually a whitecap. A high wind often tears up the crest of a swell, which turns white with foam. When the wind is especially violent, you may see the foam fly off into the air.

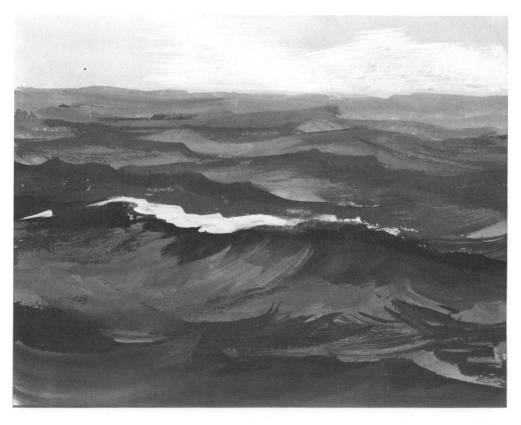

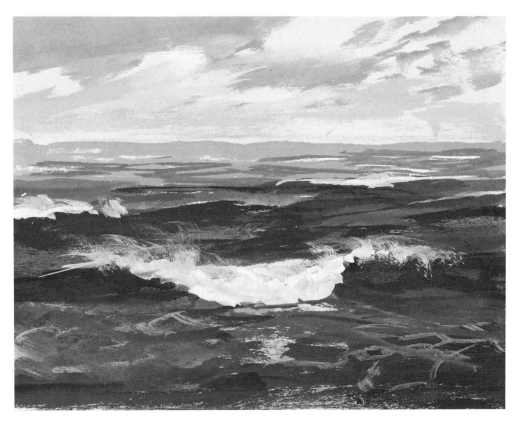

Breaker. As a wave approaches the shore, the curving face of the wave rolls over and explodes into foam. The foam often flies into the air and is swept away by the wind, as you can see to the right and left of this crashing wave. Beyond the big wave in the foreground, you can see more distant waves that are beginning to curve over and show their first traces of foam. In the immediate foreground, you can see trails of foam left by waves that have already broken.

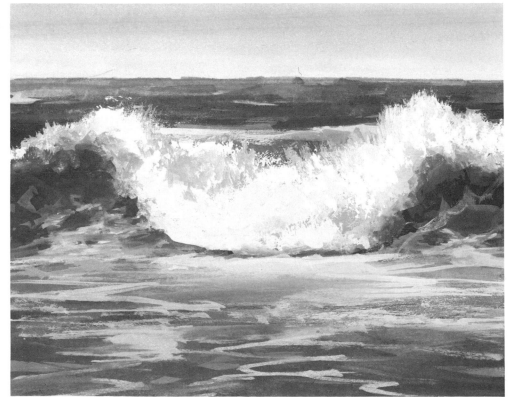

Close-up of Breaker. Here's the center of a breaking wave. The top edge of the wave has just curled forward and hit the surface of the water, producing an explosion of foam that flies upward. On either side of the crashing foam, you can see the dark face of the wave—it's dark because it's now in shadow—which will soon roll forward and explode too.

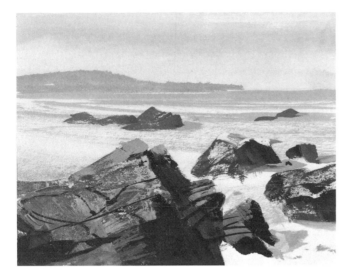

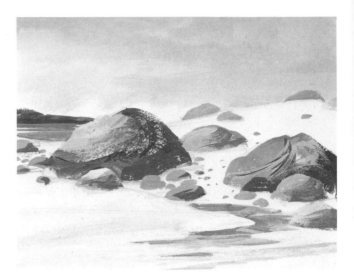

Blocky. On coastlines around the world, there are many different kinds of rocks. When you paint rocks, it's helpful to visualize them as simple geometric forms. Probably the easiest rocks to paint are the ones that look like shattered blocks, with clearly defined top and side planes. These planes tend to be fairly flat, although the blocky shapes are often tilted diagonally and half buried in sand and water. The planes are usually broken up by dark, irregular cracks.

Round. Nature also produces rocks that look more like soccer balls or footballs with their bottom halves buried in sand or water. On these curving shapes, the distinction between light and shadow planes isn't so clear. The lights merge softly into the shadows and demand subtle brushwork to show this gradation. This is when scumbling and drybrush are particularly helpful.

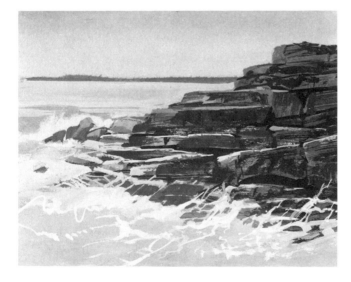

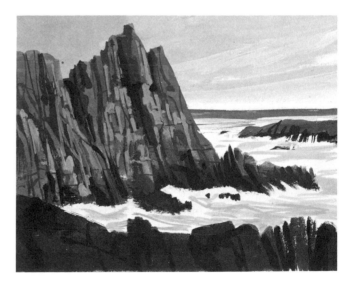

Horizontal. Rocks are often piled in horizontal strata, slab upon slab, like a badly made layer cake. These slabs tend to be blocky, with clearly defined top and side planes. So these rock formations are easy to paint if you pay careful attention to the flat planes of light and shadow.

Vertical. Nature sometimes turns that "layer cake" on its end, so the slabs are arranged vertically, rather than horizontally. The shapes of this vertical rock formation are like rectangular columns. They look complicated, but they're actually easy to paint because they have flat, clearly defined light and shadow planes.

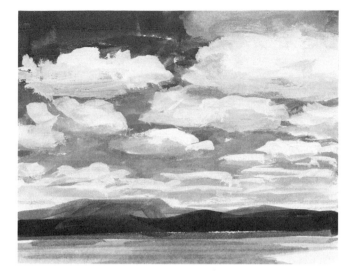

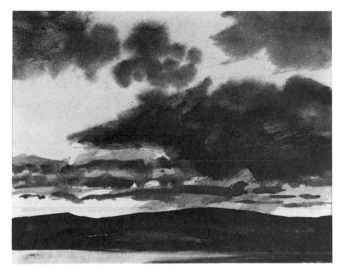

Cumulus. When you think of clouds, you probably visualize the big, round, puffy shapes that are called cumulus clouds. Because the sun is above, cumulus clouds usually have sunlit tops and shadowy undersides. When you paint a sky full of cumulus clouds, avoid making them look like a flock of sheep, all the same size and shape. Vary their shapes a bit and make the distant clouds—the ones at the horizon—much smaller than the big, nearby clouds at the top of the picture.

Storm. Storm clouds are darker and more ragged than cumulus clouds. The violent wind of the storm tears up the clouds and flings them across the sky. As you can see here, there's no "standard" shape for a storm cloud. At the top of the picture, the clouds have been torn into small fragments by the wind. The biggest cloud turns to a wedge-shape as it's pulled across the sky. And the clouds at the horizon have been torn into slender ribbons.

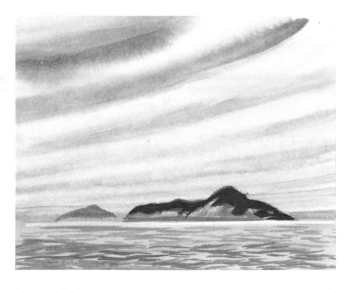

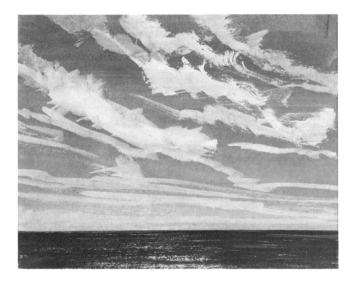

Layered. Clouds, like rock formations, often occur in horizontal layers. These may be parallel to the horizon, like the cloud layers just above this island, or they may tilt diagonally upward at one end, like the clouds higher in the sky.

Windswept. The wind constantly reshapes the clouds, creating dramatic and unpredictable forms. Here, the wind has torn the clouds into strips and then shredded the edges of the bigger clouds overhead. In painting clouds, the most important thing to remember is that each cloud formation has its own unique "personality." These evanescent shapes must be studied just as carefully as "solid" forms like rocks and dunes.

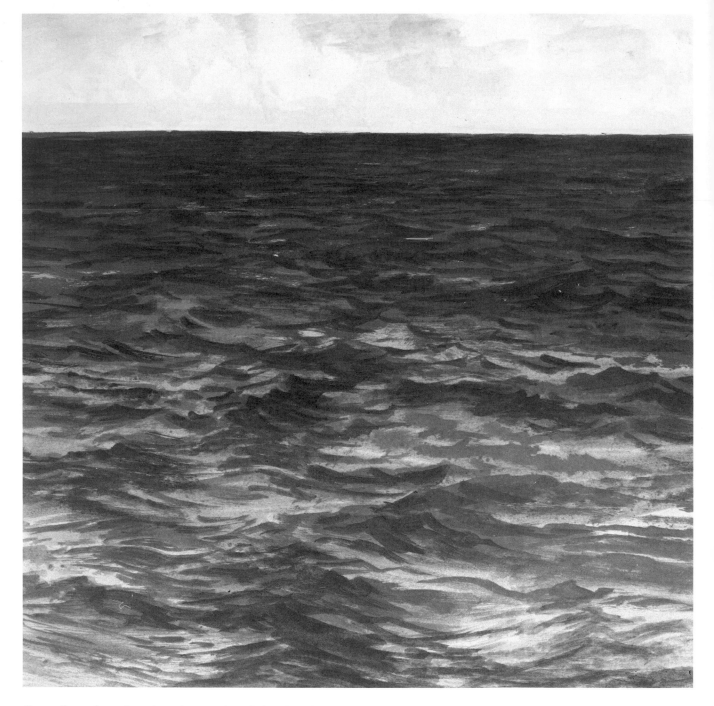

Open Sea. On a clear day, the sea often defies the "laws" of aerial perspective. You may be surprised to find that the sea is actually darkest at the horizon, growing paler in the foreground. This is probably because the more distant waves show us their shadowy faces—rather than their sunlit tops—and these strips of shadow seem to blend together on the distant water. As the waves approach us, we can see more of their sunlit tops.